CHANDELIERS

ROCKPORT

CHANDELIERS

GLOUCESTER MASSACHUSETTS

ROCKPORT PUBLISHERS

CHERYL & JEFFREY KATZ

First published in the United States of America by
Rockport Publishers, Inc.
33 Commercial Street
Gloucester, Massachusetts 01930-5089
Telephone: (978) 282-9590
Facsimile: (978) 283-2742
www.rockpub.com

ISBN 1-56496-805-7

10 9 8 7 6 5 4 3 2 1

All photography by Hornick/Rivlin, Boston,
Massachusetts, unless otherwise noted.
Design: Chen Design Associates, SF
Cover Image: Hornick/Rivlin

Printed in China.

Photo: Antoine Bootz

CONTENTS

HOW TO USE

Choosing the right accessories to complete your decorative scheme can be a daunting and difficult task. Or it can be fun, interesting, and informative. The goal of this book is to help make you more familiar with the range of possibilities when it comes to choosing a chandelier for your home, and to provide some hints for why you might choose one style over another. We're operating on three general notions. The first is that the more you know about a subject, the more comfortable you are making a decision. The second is that even though style is highly subjective—what one person finds absolutely audacious another finds truly awesome—we've assembled a whole book of really stylish chandeliers. We're sure you'll fall in love with at least one of them. The third is that sometimes, even if you know the look you're after, the sheer number of possibilities is overwhelming enough to cause catatonia just days—even hours—into the search for the perfect chandelier. This book will help you narrow the possibilities.

Which chandeliers were included in the book and how they made the cut was simple. There is not one chandelier in this book that we would not have in our own house, or that we would not recommend to our clients.

THIS BOOK

How they are organized is less obvious. They are roughly organized by style, starting with the iconic crystal chandeliers, the ones that are conjured up in your mind's eye when you say the word "chandelier." The kind that you remember from when you were a kid that seemed way bigger than it actually was. We end with the most conceptual—a chandelier that is a hologram of a light bulb. Along the way is everything in between, roughly organized by historic and material. To our mind what is more useful is that we organized by design sensibility.

That said, we hope to make the process of choosing objects to live with—things that reflect something about who you are— fun, interesting, and informative as can be. This book is intended to share the best of our finds with you. Granted, our design sensibility is pretty eclectic, but one thing we've learned as designers—and we hope we can convince you to do the same— is to keep your eyes and your mind wide open. You may be surprised by some of the things you realize you like when you approach the process in this way.

—Cheryl and Jeffrey Katz

INTRODUCTION

When we renovated our small townhouse in Boston in the late 1980s, we designed it so that we lived in the top three floors. The ground and first floors were combined to create a separate apartment. The main living space of the apartment—half a level above the street—consisted of one large room, about 15 by 25 feet (4.6 by 7.6 m), with five tall windows, whitewashed wood floors, and a simple kitchen tucked into one corner. Upstairs, in our living space, we had designed a perfectly minimal modern kitchen with state-of-the-art appliances manufactured by obscure companies. Everything was flush, even the cabinet pulls. Other than the green slate floor, everything was white. What we lacked in space, we tried to make up for in design. For the two of us, this was the perfect chef's kitchen: easy to maneuver in, plenty of counter space, efficient layout—even if the whole kitchen was only 9 feet by 9 feet (2.7 by 2.7 m).

Next to the small kitchen was a small dining room, and in it, one of our prized possessions—a 1920's chandelier with Murano glass turquoise drops. You would think we would have understood the power of light—given the number of magical meals we enjoyed under its glow—but we basically thought of the chandelier merely as a decorative object.

SEEING THE

By the time our two kids approached ten and twelve, we no longer fit into our perfectly minimal modern kitchen, but not for lack of trying. It's amazing how many times all four of us ended up in the kitchen at the same time—on school days, breakfasts were wild. What had at one time seemed perfectly minimal now just seemed perfectly tiny. When we cooked dinner for our guests it wasn't unusual to find six or seven people in our little kitchen—well-intentioned helpers, parents seeking juice for their toddlers, and foraging teenagers.

When the last tenant moved out, we decided it was time to move our kitchen downstairs. We didn't have that much money to work with as we no longer counted on our tenants' rent check every month. But we decided to see what we could do. Tucked into the corner of the apartment—a large room designed to be used by a graduate student—was a kitchen with a small refrigerator, adequate for chilling beer, and a minuscule dishwasher, just big enough for rinsing the plate used to eat a take-out meal. The stove and the sink were full sized and we figured that we could keep daily essentials in this kitchen and back up supplies upstairs. Finances also dictated that we leave the upstairs kitchen intact.

In order to make the new kitchen work, we needed to add counter space. We bought a commercial grade stainless steel worktable to use as an island and put it under the pendant fixture that used to be in the "dining area" of the apartment. The fixture itself was, well, unspectacular; a situation easily remedied by removing the glass shade and replacing it with a bamboo and paper sphere—a five-dollar version of the much more dear paper shades made famous by Isomu Noguchi. We like to think of it as a humble tribute to an artist who believed light was worthy of his attention. We put four generic wooden stools around the new island, a place to sit while chopping or for a quick breakfast. Instead of a sideboard, we bought an inexpensive galvanized steel-topped potting bench. It not only added workspace, but it was a great way to store pots and pans. We took the doors off the upper cabinets and replaced the white plastic pulls on the bottom cabinets with retro looking metal ones in an effort to transform the most basic melamine cabinetry into something that looked intentional. Wherever there was an unused wall, we put up galvanized standards and brackets to support thick glass shelves—the green edge giving an aura of design to a commercial storage solution.

For the other end of the room, where it felt like we had acres of floor space, we splurged on a modern version of a simple wooden farm table. After all, this was the part we were missing upstairs—a place to gather for dinner right in the kitchen. No need to be formal or feel removed from the action when something in the oven needed attention. Now, finally, we could gather and gossip and still stir the risotto. To surround our new table we brought down the most comfortable chairs we had in the house—slightly over-scaled restaurant chairs from the 1940s. And though this upstairs left some of the rooms feeling a little spare, it was well worth robbing Peter to pay Paul.

Three weeks after moving into our new kitchen, we were sitting at the stainless steel island on our extremely uncomfortable wooden stools, having dinner with our friend, Helen. We told her how much we liked our new kitchen, but how old habits die hard. The four of us were so used to being crammed into our little kitchen upstairs that we never left the working end of this kitchen. We always sat at the island and never at our new kitchen table. She said, "When are you getting a chandelier to put over the table?" Helen asked. "Don't you know that everybody gathers around light?"

It had never occurred to us that we didn't use the kitchen table because it didn't have the warm glow of a chandelier to gather around. We had simply been depending on ambient light from the rest of the room. But Helen was right. The table that we had so long counted on to be our gathering spot didn't feel like one. We're happy to report, that many long happy meals later, seated at our comfortable, well-lit, kitchen table we laugh at the irony that here we are, writing a book on chandeliers. We finally have seen the light.

The **U N I Q U E** proportions of this

Czechoslovakia-made chandelier, 30 inches

(75cm) high and 12 inches (30cm) in diameter,

are well suited to a room with high ceilings.

When we think about ballrooms or grand

European hotel entrances, this is the chandelier

we imagine. Not only does the column of

crystals sparkle, the scale of the chandelier

requires a room of grand **P R O P O R T I O N S .**

If you don't happen to live in a castle, there are

many small versions of this kind of chandelier.

↔ Proportion is key when choosing a chandelier. Think about the visual space a chandelier uses as well as its actual measurements. Density—the weight and heft the chandelier brings to a room—is an important considera-tion. Like all good decoration, deciding on the appropriate size of a chandelier has a lot to do with trusting your instincts and your eye. A seemingly small chandelier covered with crystals, beads, and decorative ornaments takes up more visual space than a delicate wrought-iron one, even if the measurements of the wrought-iron chandelier are actually larger.

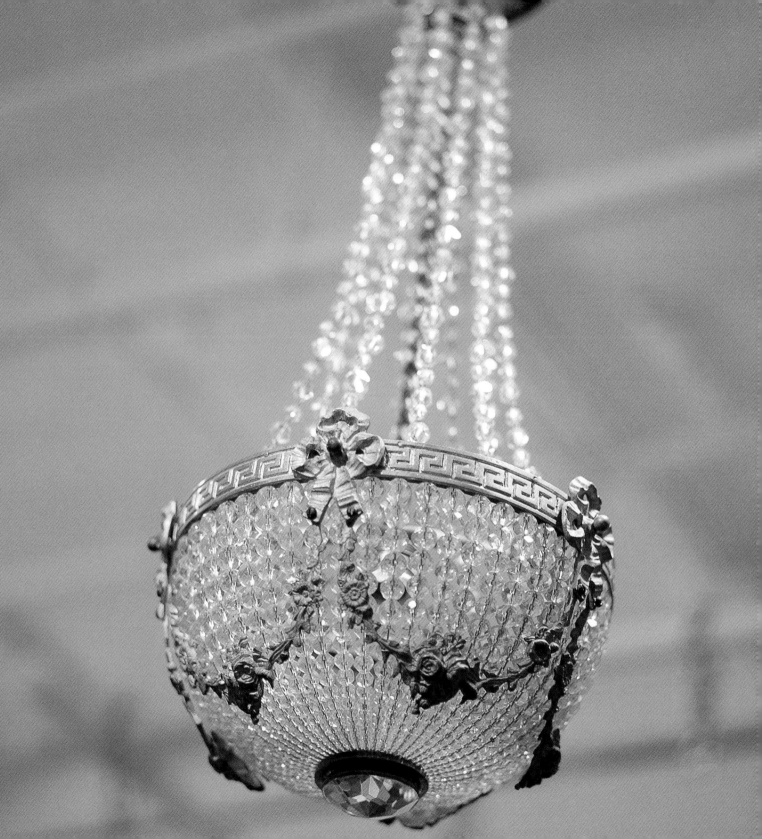

Crystal chandeliers have a

MAGICAL

quality. Because of the

many facets in each piece

of glass, crystal chandeliers

break light into brilliant

prisms of color. The twinkling,

SPARKLING

effect this light lends is

enchanting.

↔ Controlling the amount and quality of light in a room goes a long way to contributing to the room's ambience. If you're having a small romantic dinner for two, turn off the overhead light and light the table with candles. It may seem too dark at first, but you'll be surprised at how quickly you and your guest will adjust to the low light level. Use an antique candelabra to create the kind of formal setting appropriate for a marriage proposal. For a more casual intimate setting, light dozens of votives and put them all over the room. If you're setting the mood for a big glittery cocktail party, light the room brightly. Keep in mind that lighting from many small sources around the room—floor lamps, table lamps, sconces, and candles—will create pools of light and a more elegant effect than if you just rely on the overhead light from your chandelier. Using multiple light sources will provide enough overall lighting to see and welcome your guests from across the room as they arrive, while still creating areas for the most private a tête-à-tête.

↔ The simplest dimmer can be installed by replacing the on-off switch of the chandelier with a dimming toggle. However, many manufacturers now make sophisticated dimming systems that have pre-set scenes. Overhead fixtures, sconces, hidden cove lighting, and even table lamps can all be controlled from one point, each new combination creating a different mood for the room.

The combination of light from a crystal chandelier and candles ensures a dinner party that emanates W A R M T H . Everything in the room, from the china to the guests, sparkle. To get the ambience just right use a dimming system to help regulate the amount of light in the room.

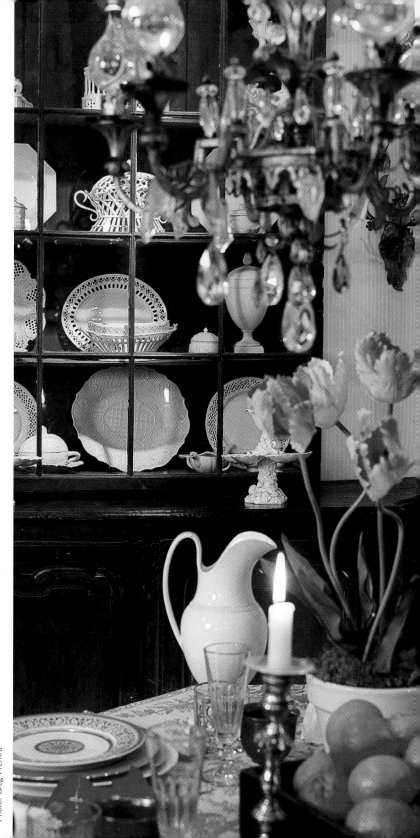

Photo: Greg Premru

This chandelier from the 1920s is reminiscent of the

F R E N C H Directoire style. At first glance you

might imagine it in a room inhabited by women in

sheer empire waist gowns and men in high-waisted

jackets and tight trousers. Instead, consider how mod-

ern this chandelier would look in a spare, white loft.

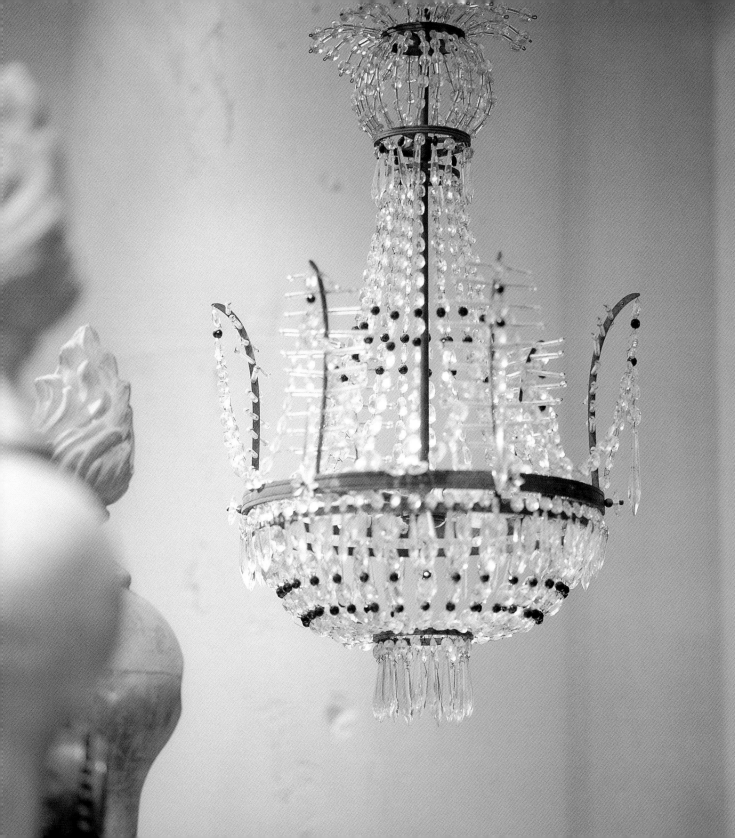

CRYSTALS

Crystals, those glittering, sparkling jewels on a chandelier, are actually pieces of glass that act as prisms refracting light as it passes through the glass's many facets. The original crystal of the sixteenth century was rock crystal, a form of quartz that could be cut by hand. Today's crystal may have lead oxide added to soften the glass for more precise machine cutting or it may contain no lead if the crystal is to be cut by hand.

Instead of thinking of crystals as the serious part of a chandelier, consider them as freewheeling decorative elements. All the crystals don't have to match. Imagine beginning with just the metal frame and a color scheme—let's say you've settled on amethyst and clear crystals. The frame will give you some idea of scale and the color scheme will allow the finished fixture to be an active part of the decorative scheme for the room. Every time you pass a store that carries antique crystals, stop in to see if they have any that are suitable. In no time at all, you'll have more than you need. Now comes the task of specific placement. Hang the fixture in the space and use a trial and error process to place the crystals. The outcome will surely be unique.

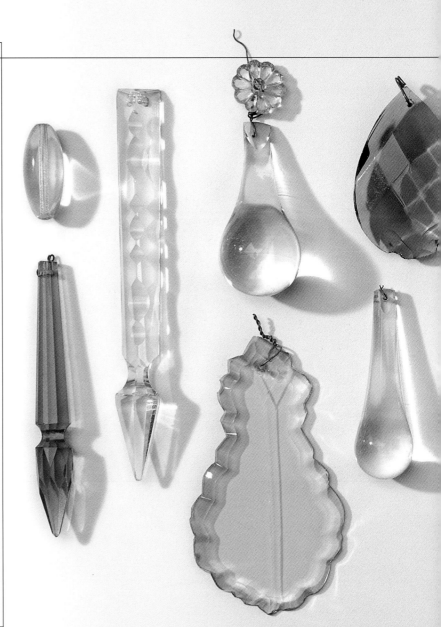

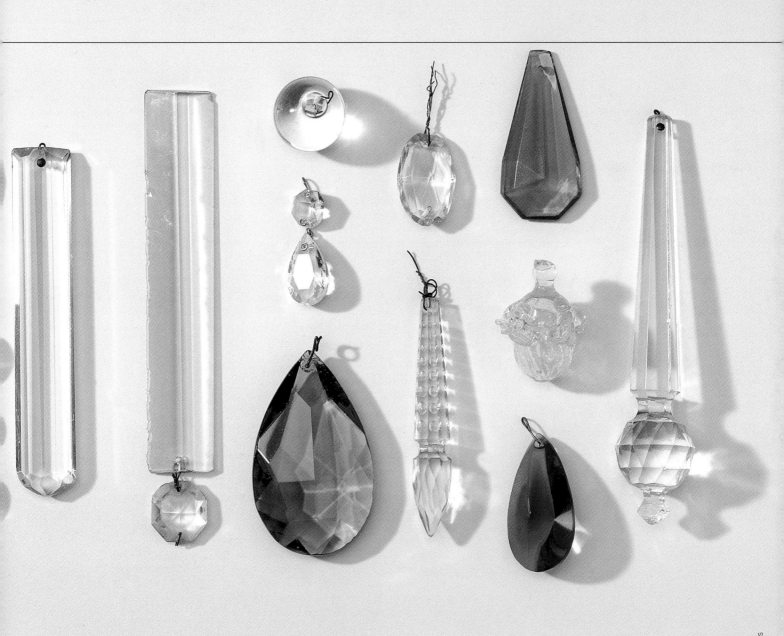

At first pass, you might not consider this crystal chandelier appropriate for a living room. But, with the room's eclectic assortment of furnishings, from the antique chinoiserie cabinet to the oversized, modern black lacquered coffee table, the chandelier turns out to be a perfect addition. Even during the day when the lights are off, this chandelier is at work, pouring **RAINBOWS OF LIGHT** on the white walls.

↔ If the word "eclectic" best describes your decoration scheme, a chandelier can go a long way to pulling together what might seem otherwise like disparate elements. If traditional rules of decorating say that each piece in a room should have a similar tone and provenence, use a chandelier to break the rules. If you have inherited a beautiful English crystal chandelier, don't feel that you have to complete the room in a similar vein. Depending, of course, on the particulars of the piece, it may work perfectly well in a room otherwise described as, in the case of the room shown here, chinois. A room with period furnishings might well be enhanced by the addition of sleek contemporary lighting. If the chandelier is strikingly different than everything else in the room, you may want to add some other accents that tie it in. The art in the room may be a place to continue the eclectic mix.

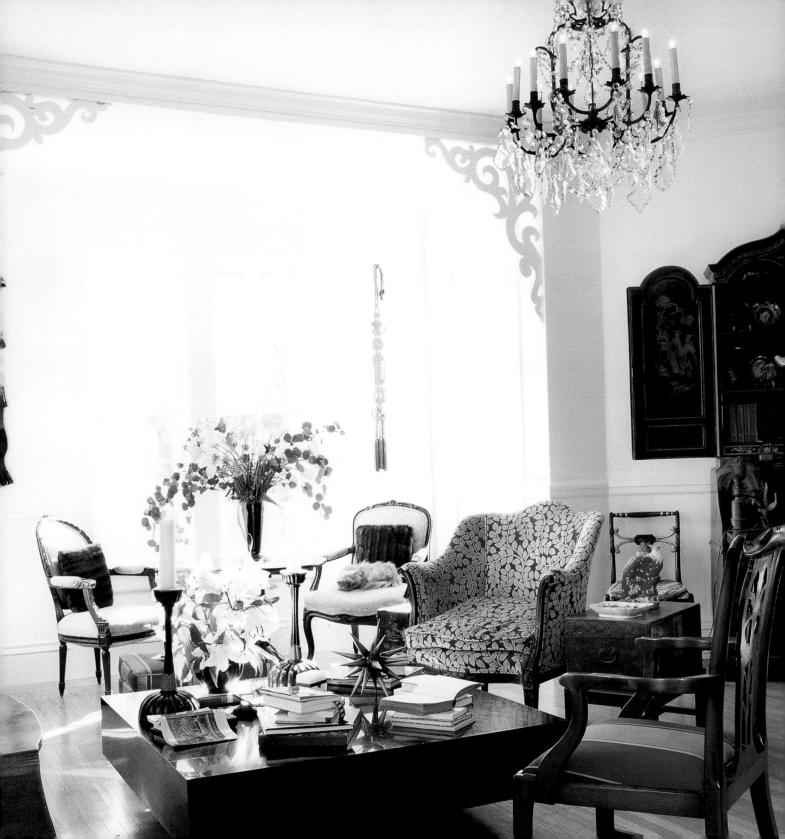

An **O R N A T E** crystal chandelier adds an unexpected and sophisticated touch to a country-inspired dining room. It is a great foil for ladder-back chairs, a farm table, and simply framed Japanese prints.

↔ There was a time when rooms in a large house had names like saloons, great halls, or antechambers. Furnishings were often flexible, arranged against the wall so that they could be set up according to the activity that was to take place in that space, usually some form of entertaining. Nowadays, we tend to assign specific functions to rooms and then furnish them accordingly. Dining rooms, for instance are rarely used for anything but dining. But if you have high ceilings and a large enough room, you can keep it flexible. Hang the chandelier high enough to walk under without hitting your head. Rather than a standard 7-foot (2.1 m) or 8-foot (2.4 m) dining table with leaves, use a gate-leg or tilt-top table—something that breaks down and can easily be moved off to the side. Now the room can be used for groups larger than could be accommodated around the dining table. Use the room for a cocktail party or buffet dinner or set up a handful of smaller tables for a bridge party.

As you ascend the stairs you get a glimpse of this small crystal chandelier, a prelude to the rest of the decor in the room that it lights. Hanging it close to the ceiling gives a sense of

SPACE AND HEIGHT

to the room, and unlike the typical dining room setup, the chandelier has not been married to the placement of a table, allowing the arrangement of furnishings and function of the room to be changed at a moment's notice.

Daylight has universal appeal. We flock to beaches to bask in it all day. We sing about it: "Life can be so sweet, on the sunny side of the street." Sunlight makes people happy. When we don't get enough of it, we feel depressed. There are mood-altering therapies that involve exposing patients to light in order to alter their mental and emotional states.

LIGHT

But in its pure unadulterated state, its intensity can be too much. Colors become sun-bleached and fade under its intense glare. Land becomes parched. It is sometimes easier to appreciate sunlight in its somewhat less-than-unadulterated state: when it becomes dappled through leaves, for instance, on a path in the wood, or when it breaks up into twinkling points of light on the surface of moving water. A shaded porch looking onto a sunny meadow is the ideal way to wile away an afternoon. The ocean serves as a counterpoint to the sun for a long day spent at the beach.

Natural Light

Daylight is a luxury. One could construct a history of modern architecture as a quest for light: using larger and larger panes of glass to dematerialize walls of buildings and allow them to be as transparent as possible. Alas, no matter how much glass surrounds you, the sun will eventually set, leaving the inhabitants to their own devices.

Upon nightfall, our perception of the world changes. As the sun sets and as lights are lit inside, windows become mirrors, and our visual perception of the world shrinks to the plane of the glass in the window. Everything beyond is black, so the quality of the light sources that we gather around becomes very important to nighttime activities, whether a festive dinner party or a restful read.

Artifical Light

The same things said about sunlight translate to artificial light. Pure unadulterated, unfiltered light is harsh and unpleasant. Think of rows and rows of fluorescent lights in open office areas. They may be energy efficient, but their unchanging glare is unpleasant at best. In our design studio, there is a bank of twenty windows along an east-facing wall. Everything inside the studio is painted white. Arriving at the studio on a sunny morning is like stepping into a light box. By ten o'clock the direct sunlight is gone, but the space is filled with reflected light. Even on cloudy days, nobody in the studio ever uses artificial light. But by four o'clock on a winter day, we are usually sitting in a fair amount of darkness—the last of the dusk on the horizon—but for pools of incandescent light from task lamps on each desk and from the glow of the computer screens. For any other task than desk work, it becomes necessary to use, awful as it is, the continuous unshaded double tube of fluorescent fixtures that run the length of the studio. It gives adequate light for searching the materials library or loading paper in the printer, but nobody can wait to finish the task and turn off the fluorescent light, returning us all to our warm pools of incandescent glow.

Diffused Light

Like the problem of glaring sunlight, one big direct light source is rarely the best kind of light, unless of course you're undergoing light therapy. But like the glittering light that reflects off water, or the reflected light of the shaded porch, there are all sorts of devices to reflect, refract, diffuse, and otherwise soften direct light. Our lighting system, once deemed acceptable, is now hopelessly out of date. Even fluorescent light, mostly used in commercial spaces, has been made far more pleasant by being directed upward, reflecting off the plane of the ceiling and giving an even, diffused glow.

Chandelier Light

The indoor version of the dappling of light through trees, is created by chandeliers. In their pre-electricity days, when they would give light from burning candles or oil, there was a romantic quality to the flickering light they provided. Electrified chandeliers try to replicate the gentle flickering of candlelight or the warm glow of oil lamps by using multiple small incandescent light sources rather than one large source. The lamps are often surrounded with materials like prisms or crystals that refract the light, or silk shades that diffuse it. Often chandeliers have both. Usually the crystals are attached on small hooks, allowing them to move with air currents and sending sparkles of light around the room. More contemporary chandeliers achieve similar results with frosted glass, colorful hand-blown glass, or even with paper.

Magical dinner parties are mostly the result of the guest list and the menu. But don't underestimate the importance of light. Clever repartee and delicious food seem all the more so under the warm glow of an elegant chandelier.

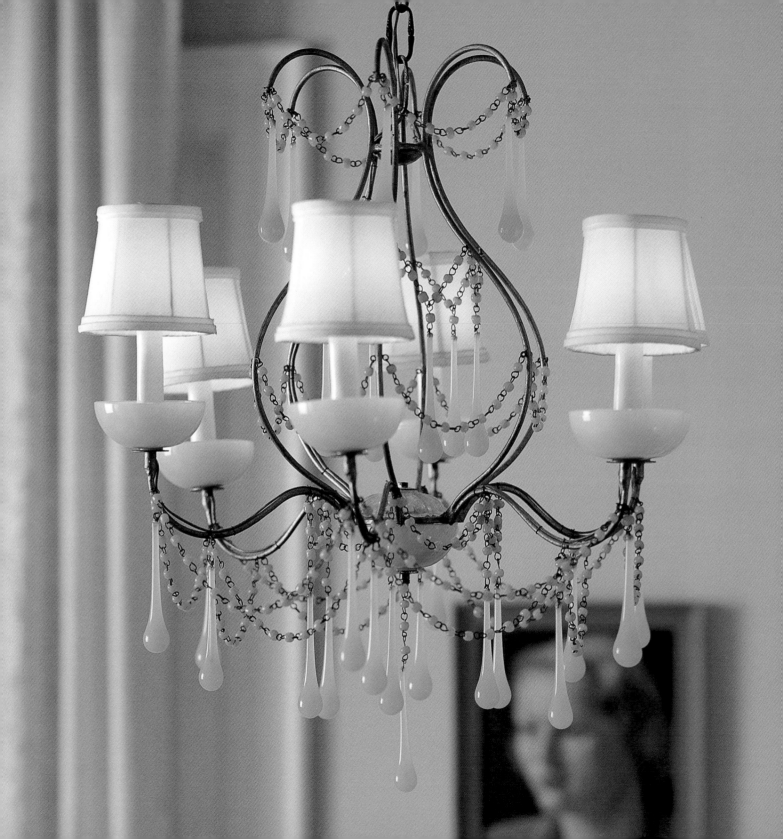

A NECKLACE

of aqua beads and glass drops covers this charming chandelier. To complement the unusual color, the walls were painted new-grass green and adorned with a pink-framed portrait of a woman in a green dress. Rather than leave the bulbs exposed, shades are used to meld and soften the room's unusual color scheme.

↔ When we design a room, we start by choosing a palette. Usually, we consider the room's "envelope"—the wall, floor, and ceiling color—first. Once this is established, we determine the rest of the palette. We introduce color in the fabrics we choose for the upholstery and window treatments. We reiterate the palette in the choice of the accessories—accent pillows, throws, or lampshades. But if there already exists a unique item in a room's decor, like this aqua chandelier, use it as the starting point for the palette.

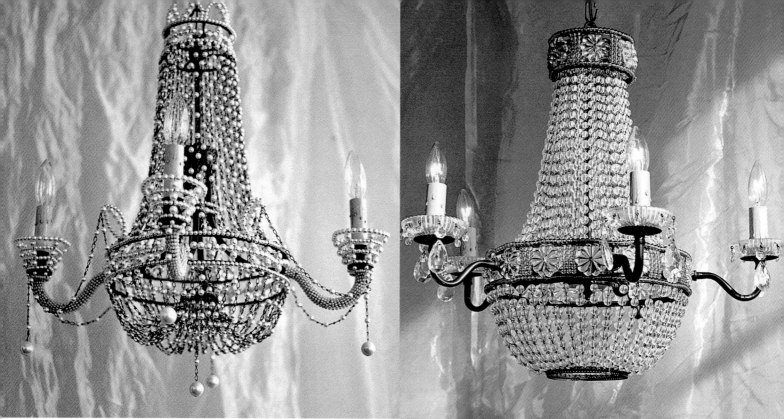

Inspired by Paris flea market finds, this group of

UNIQUE beaded chandeliers is made in New

York by Canopy Designs. These over-the-top
pieces help create dining rooms that are elegant,
entrance halls that are dramatic, and bedrooms
that are purely romantic. When bejewelled and
beaded chandeliers are used in unexpected
places—small powder rooms or clubby dens—
they add an element of surprise.

*(Top row, left to right: French Wyre Venetian,
Delezenne, French Wyre Ballon, Florentine. Bottom
row, left to right: Crystal Petal, Venetian, Florentine)*

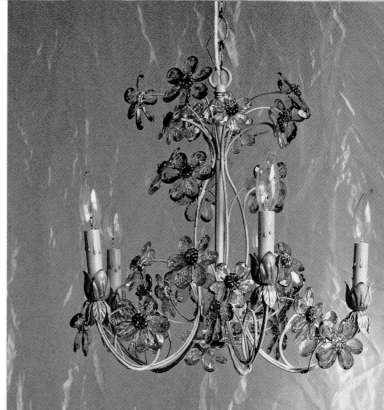

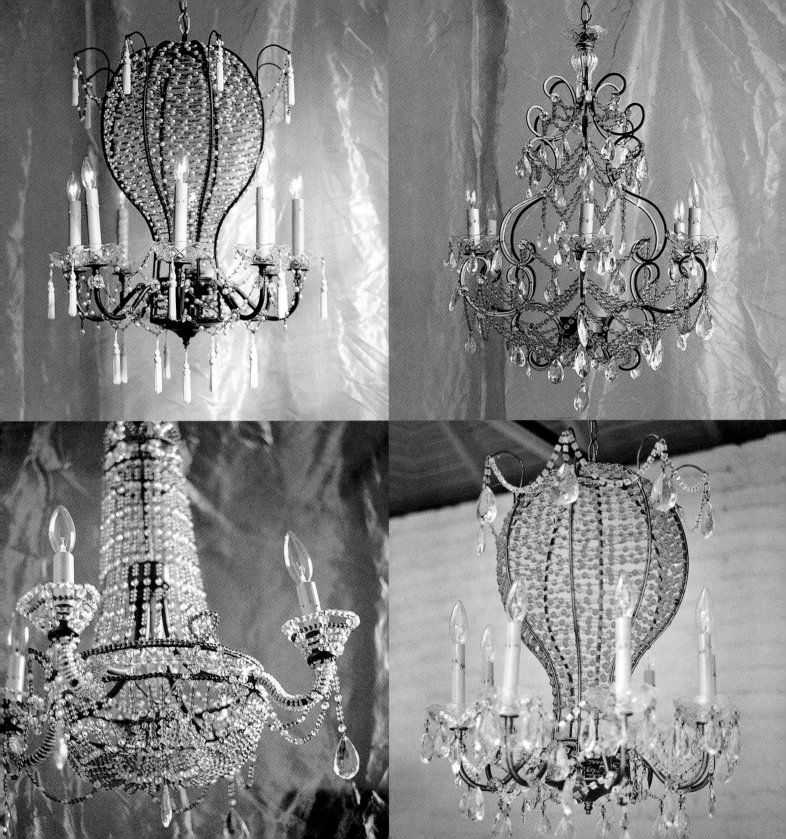

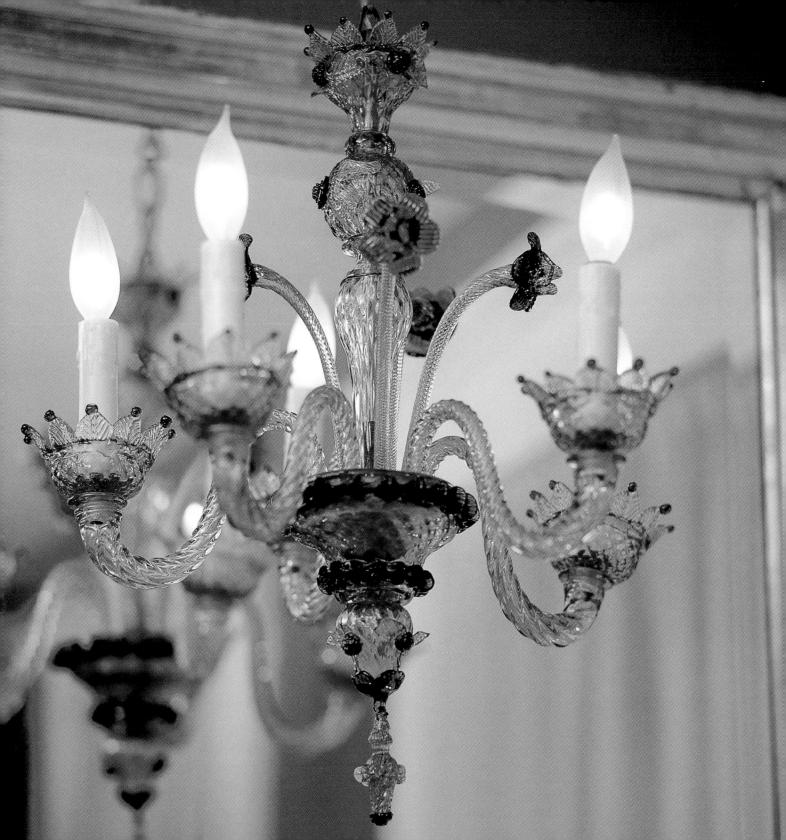

Murano, one of the small islands
that make up Venice, has long
been revered for its hand-blown
glass objects. Murano glass
chandeliers are no exception.
The intricate decoration on this
1940's chandelier—twisted glass
arms, flowers, ornate pendant—
make it a perfect choice for a
room that is minimally furnished.
Think of it as a spectacular
piece of J E W E L R Y
with a simple black dress.

Another take on Venetian glass is this **ELEGANT**, highly restrained, 1950's chandelier. Simple sheer wool drapery panels are the perfect backdrop for the refined proportions of the piece. The amethyst color is soft enough to work in almost any palette and gives the glass more **PRESENCE** by sending colored shadows to the walls.

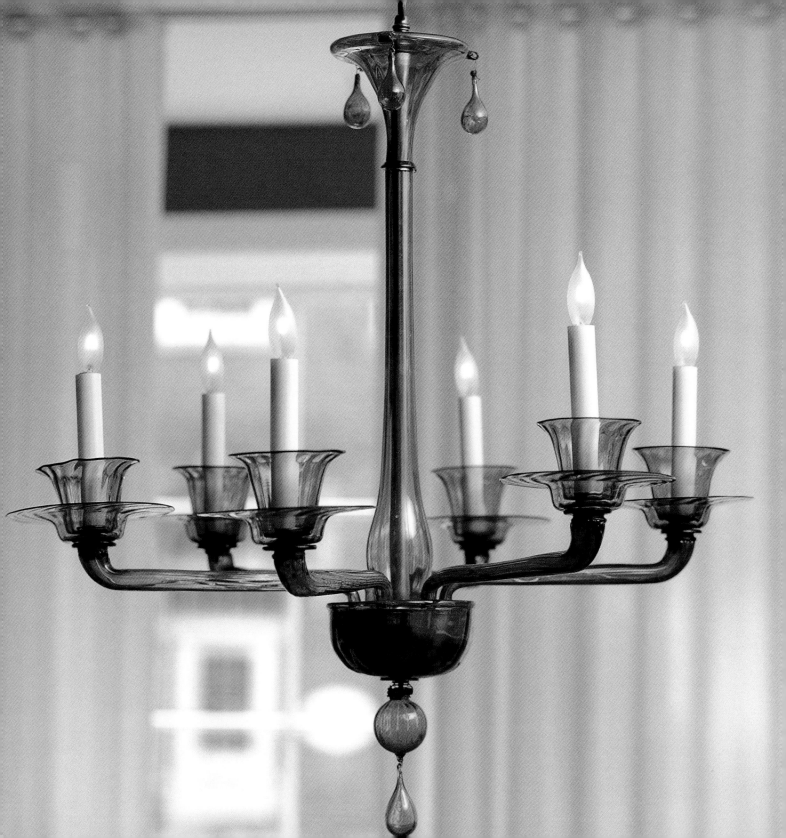

This modern, strictly designed home office is softened by the addition of a fabric chandelier. The upside-down, pagoda-shaped shade, with its references to Ottoman textiles and sixteenth-century Venetian fabrics, is punctuated by a Murano glass drop.

↔ Consider a chandelier like this one as you might a favorite item in your wardrobe. When you know you're going to wear it, you design the rest of your outfit around it. It is probably different from most of the other things in your closet and likely not something you'd wear everyday. Nevertheless, it delights you every time you put it on. No wonder, then, that this fixture was designed by Mariano Fortuny, who was probably more well known for his classic dresses and fabrics than for lighting. Use a chandelier like this as you would one of his gowns—save it for special places in your house. Design a room around it because it will undoubtedly take center stage.

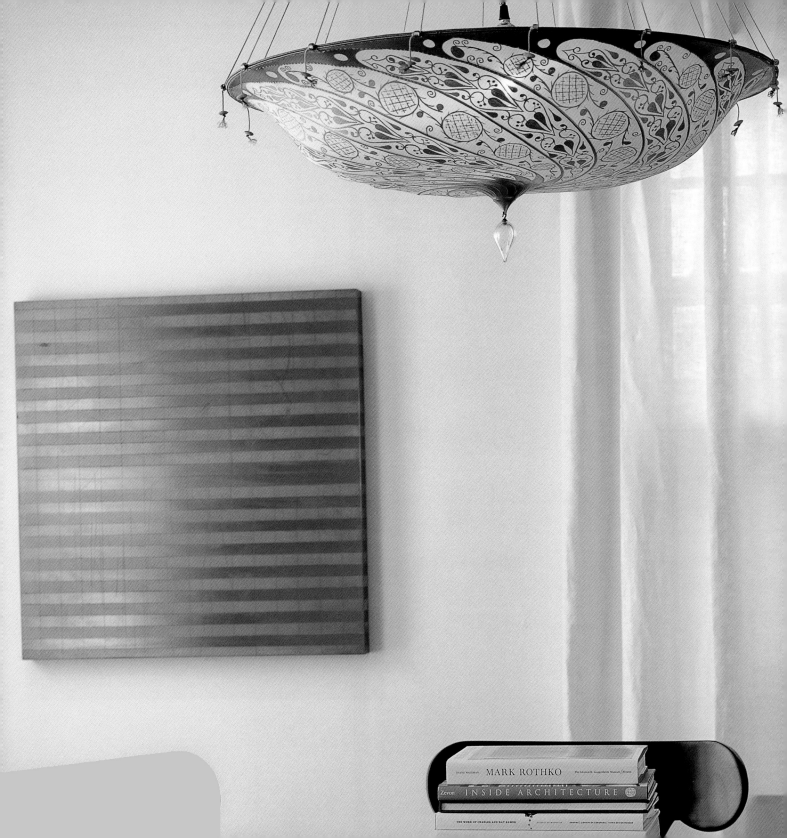

This 1940's glass-and-silver-plate chandelier comes from a small decorating shop on the Faubourg St. Honore in Paris. An elegant take on the glass lantern, it could be used either in an entrance hall or over a dining room table. This style is often thought of in more traditional settings; however, the

SLENDER SILHOUETTE

and the fact that the fittings are silver rather than brass make it a natural choice for a modern interior as well.

Most of us have been choosing our clothes since we were teenagers. So it's not surprising that it seems considerably easier to put together a wardrobe than it does to put together a room. Yet, the same basic principles apply.

Getting the Look

Look at it this way. In both apparel and interiors, there are two basic design approaches. There are those who like their clothing and accessories to be consistent from top to bottom—one "look" for the dress, the shoes, even the earrings, one "point of view" for the jacket, the trousers, the shirt, the tie, and the belt. The same could be said of a room. There are rooms where the furniture and the accessories have the same sensibility. They might share a similar provenance or historic reference. For example, an Arts and Crafts dining table and chairs and a leaded-glass chandelier may be enveloped in a William Morris wallpapered room. And though the consistency produces both chicly dressed people and elegant rooms, we prefer using the other design dictum: The "throw-the-room" approach.

In a 1930's Cecil Beaton photograph of Gabrielle "Coco" Chanel, the legendary fashion designer is seen reclining on a divan, wearing a simple round-necked sweater and slim skirt. What defined this image as a fashion moment was the way Chanel wore accessories—multiple strands of pearls, chunky wrist cuffs, and jewel-encrusted earrings. The addition of these accessories to an otherwise simple ensemble "threw" the look. Juxtapositions of seemingly disparate elements—in Chanel's case restraint versus flamboyance—defines this approach.

How to "Throw" a Room

Let's apply the same design process to a room. Architecture and provide the basic look of a room. It is the height of the ceilings, the proportion of the windows, and the size of the moldings that begin to define the character of a room. The finishes establish the next level of character. Floral wallpaper, or gray, industrial wall-to-wall carpeting, or mahogany paneling, confirm the room's look. Then add the major items of furniture: the sofa or the dining table or the bed. We always advise keeping the major elements fairly sober. No need for a really zany sofa when a few zany toss pillows and a throw will achieve a livelier, less obvious room. An irrational affection for something zany may be shorter-lived than the investment in a sofa would justify. Accessories are the right scale to experiment.

STYLE

The Art of the Unexpected

Once the basic look is established, finding the unexpected accessory, whether for your wardrobe or for your room, can be tricky and time consuming but it's well worth the hunt. Of all the objects that are put in a room, the chandelier offers the most possibilities for surprise—for "throwing the room." A chandelier is a room's jewelry. Like a stone-encrusted brooch, it adds sparkle. Like a strand of pearls, a chandelier makes something simple—say a casual Wednesday night supper in the dining room—feel special.

Defining a Style

An over-the-top, fancy crystal chandelier in an otherwise sleek interior can make a room more interesting. An oversized gilded metal chandelier in a small country cottage is pure romance. Modern chandeliers defy definition. Not the least bit standard issue, modern chandeliers employ materials like aluminum, sand-blasted glass, polypropylene, cotton, and paper. These need not be reserved just for loft living. The sleek simple profile of a modern chandelier in a Shaker-inspired interior or an American farmhouse. The ubiquitous brass chandelier in a traditional room is a much more intriguing addition when it has a matte finish.

Like a woman in a stylish hat, a chandelier is often made more charming by the addition of shades. Adding an elaborate shade to an already elaborate chandelier may seem like "gilding a lily," but sometimes too much is just what you want. Sometimes, like Jackie's famous pillbox hat, an elegant linen shade on even the grandest chandelier is just right. Or consider the opposite approach: add braid-and-bead-trimmed, pleated, striped silk shades to a simple brass chandelier to great effect. Or put whip-stitched parchment shades on a modest, black wrought-iron fixture. Which of these methods works depends on how comfortable you are with an eclectic sensibility. It depends on how much you want to "throw" the room or how much you want to be in keeping with the rest of the furniture and accessories. Whichever you choose, one thing is sure about the addition of shades: Whether you're using them to dress up a basic chandelier or to dress down an ornate one, shades will soften and diffuse the light while they top off the look.

As is typical in an early-nineteenth-century Boston townhouse, the stair hall is small to save space for the impressive rooms that surround it. What might be the obvious choice in this situation is a brass lantern, but the sophisticated decor of the house demanded something more stylish. From a distance, this 1920's French ART DECO chandelier seems quite simple, but a closer look reveals intricate, elegant detailing— the four arms are fluted, tied and, tasseled. Though small, the nickel chandelier's strong vertical silhouette is a perfect shape for a formal, narrow stair hall.

↔ The shape of a six- or eight-arm colonial brass chandelier is what you probably have come to think of as typical. But as this fixture attests, chandeliers come in many shapes—though you may have to dig a little deeper into your lighting resources to find one that works. Broad chandeliers, which are wider than they are high, work well in a large room with low ceilings. If you're using it in a dining room, however, proceed with caution. If a chandelier has a much-larger-than-usual diameter, it will probably work better over a large square or round table than over a rectangular one. High, narrow fixtures—like the one shown in this hallway—are more forgiving. But make sure the room has the height to accommodate it. The bottom of the fixture has to be high enough for diners to see across the table without visual obstruction or glare from the chandelier.

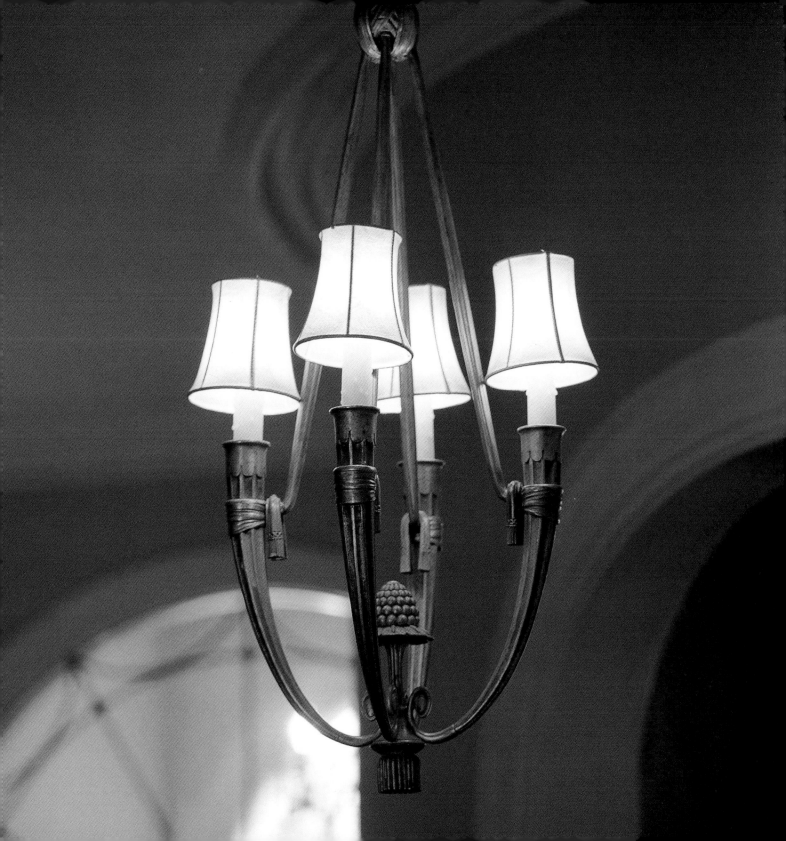

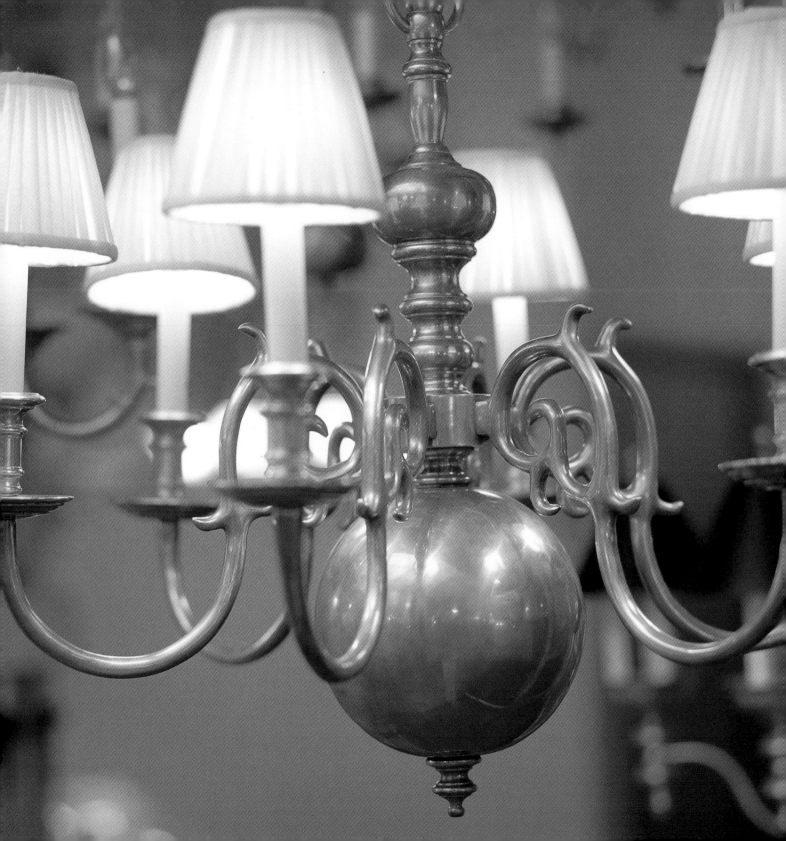

This brass chandelier, adapted from a seventeenth-century candelabra, is updated—ironically—by an unlaquered, matte finish. It takes a clear design sense to decide to let brass fittings tarnish, but often finishes that are called antique brass are, in fact stable, the tarnishing process kept in check. This is often a much better alternative to polished and lacquered brass, which can look gaudy. PATINATED surfaces seem warmer and more inviting, as if years of use have given them character.

SHADES

In the past few years, clip-on shades for candelabra-based bulbs have become fashion-able, making them much easier to find. They can be used to dress up a simple iron chandelier, or to add one more level of detail to an already elaborate design. There are simple linen or parchment shades that might be used simply to soften the light, but these more decorative shades—some made with clear faceted beads, others with amethyst or amber ornaments or toile de jouy fabric—will change the whole effect of a chandelier, making it more prominent in the room's decor.

 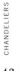

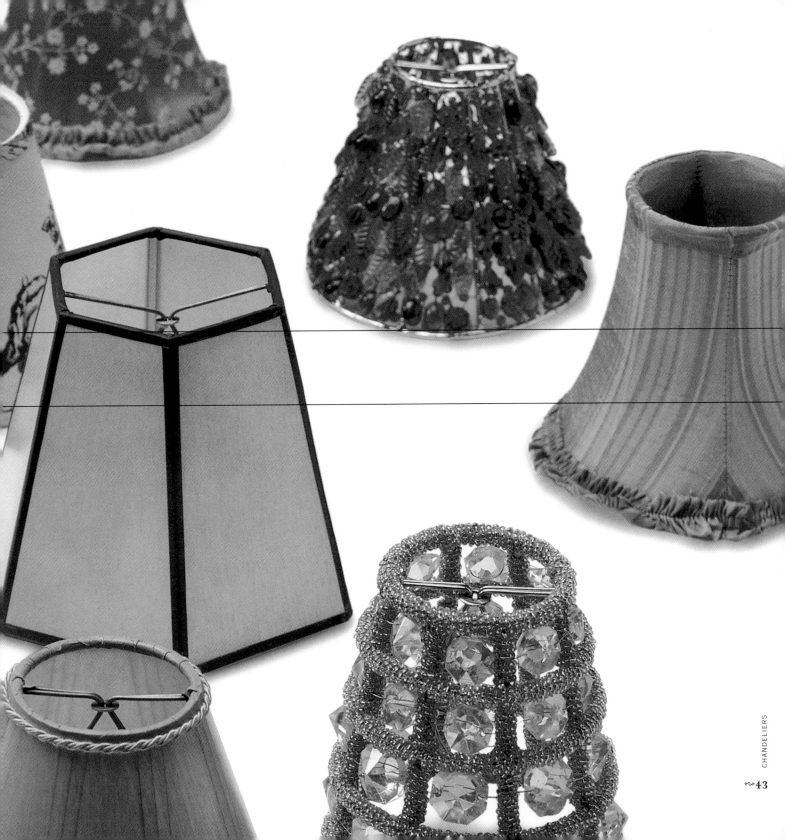

The soft glow cast from a simple
iron chandelier with mica shades
reiterates the W A R M T H
of richly colored walls and wood
cabinets. Mica, parchment, and
handmade paper shades are
excellent ways to soften and
filter light.

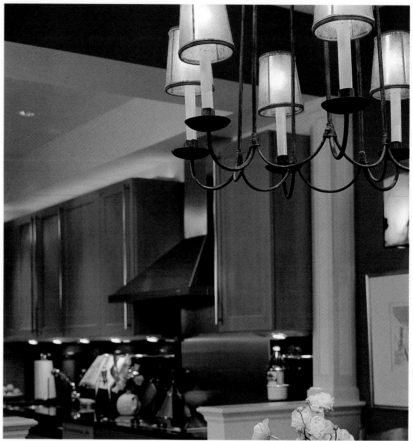

↔ Unless you're specifically striving for the cool, white light from fluorescent or halogen bulbs, creating a warm atmosphere is generally the desired effect when designing a room. Lighting that uses incandescent bulbs, especially when they're shaded by warm-colored materials, help induce the feeling of warmth. But lighting isn't the only consideration. Warm colors on the walls have the most drastic effect, which is why yellow and peach are popular colors. But dark colors, even in cool shades like forest green or aubergine, can have a similar effect by shrinking the scale of a room and making it feel more intimate. Almost any kind of wood in a room significantly increases the psychological warmth factor. Dark reddish-brown woods like mahogany and cherry are obvious candidates. But even lowly plywood, a material only recently used as a finish material, will bring warmth to a cool white room.

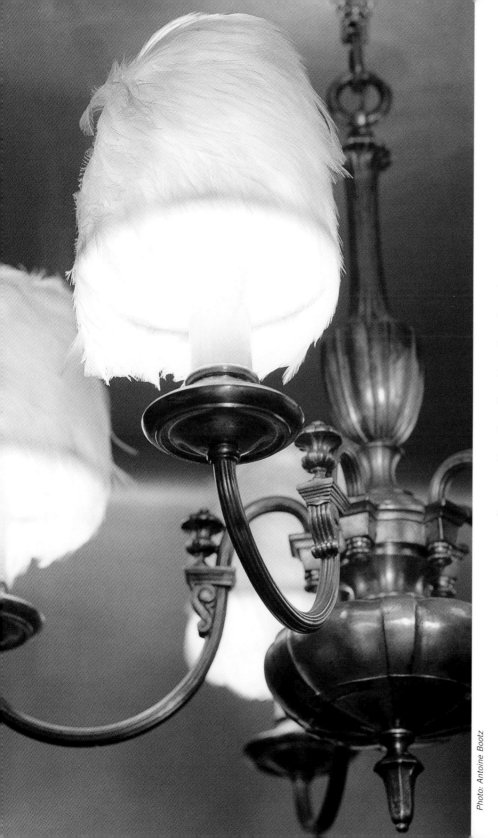

Photo: Antoine Bootz

These shades, covered with feathers, are a great addition to a traditional chandelier. Simple shades can be embellished with a host of materials—buttons, bows, ribbons, beads, seashells. The

POSSIBILITIES

are endless.

An Arts and Crafts inspired

chandelier is part of an **ECLECTIC MIX**

of furnishings that include

aluminum dining chairs and

an antique oak dining table.

The chandelier is hung slightly

higher than is usual, providing

an unobstructed view of the

painting on the wall behind it.

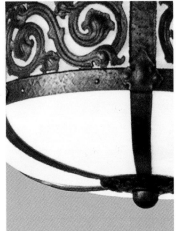

Photo: Greg Premru

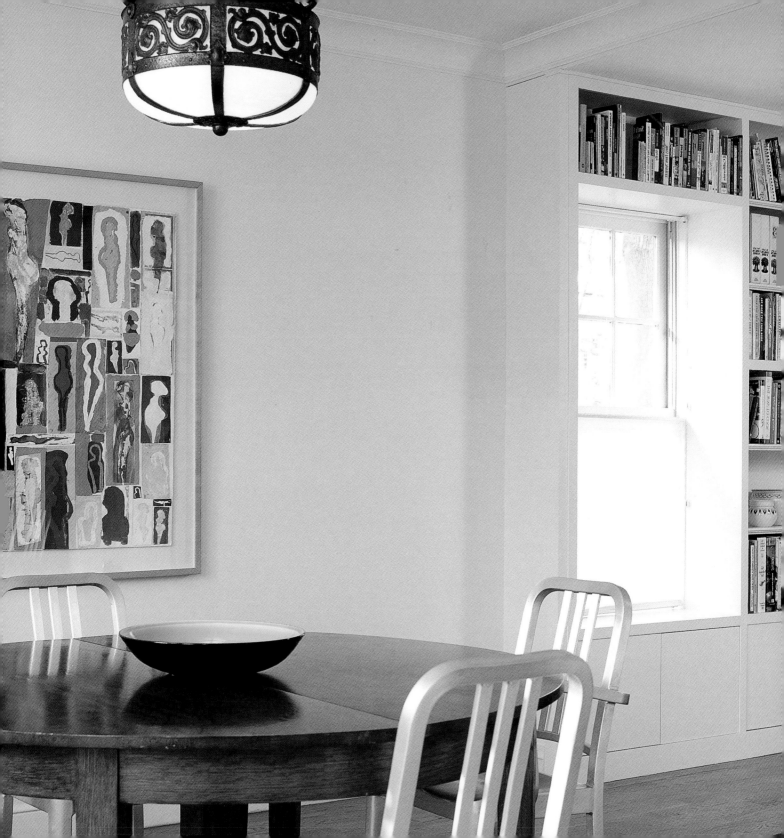

In a living room with a beamed ceiling, the best lighting S O L U T I O N

was a U N I Q U E chandelier fashioned from a flat, rusted,

decorative metal grate. The candle slips are perched at the outer

edges of the thin plane of metal, allowing the light to reflect off the

white ceiling. The small overall height of the fixture allowed it to be

hung over a pair of sofas, even in a room with low ceilings, and be

comfortably above head height.

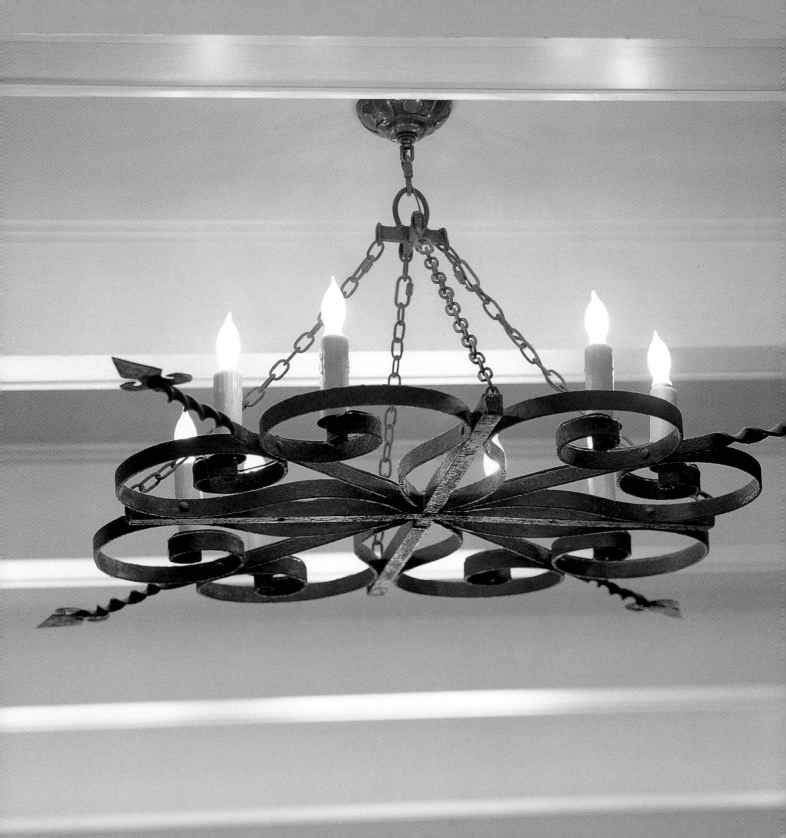

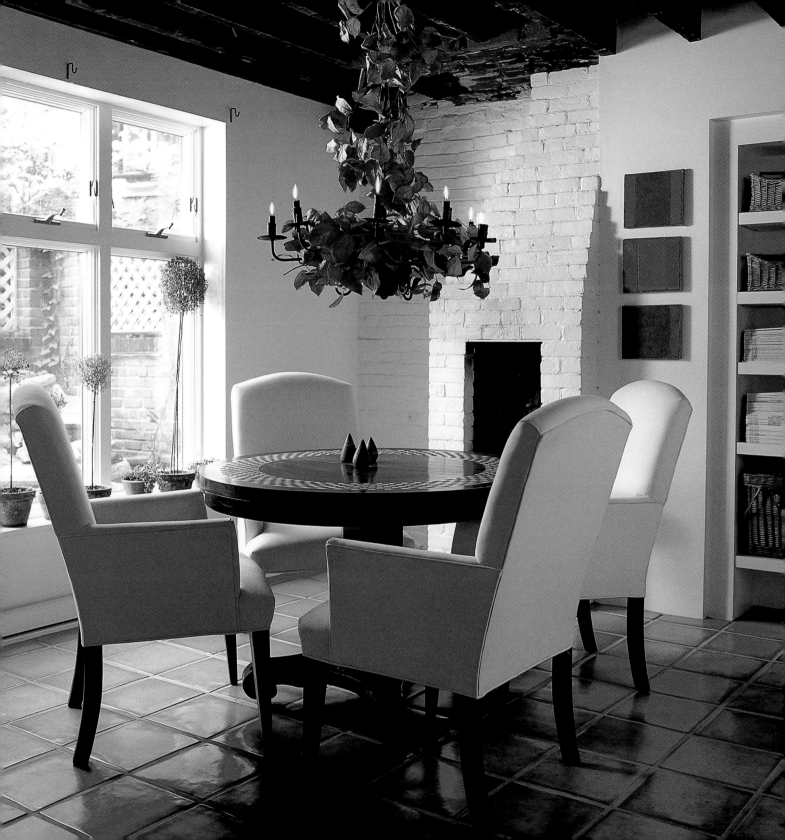

If you're tired of a chandelier, if it feels out-

dated, or if it's time to throw a party, try

DECORATING IT.

To create a garden feel, this simple iron

chandelier was wrapped with branches and

leaves. Adding dried fruit and berries also

works. For a more colorful effect, string a

chandelier with beads and glass ornaments.

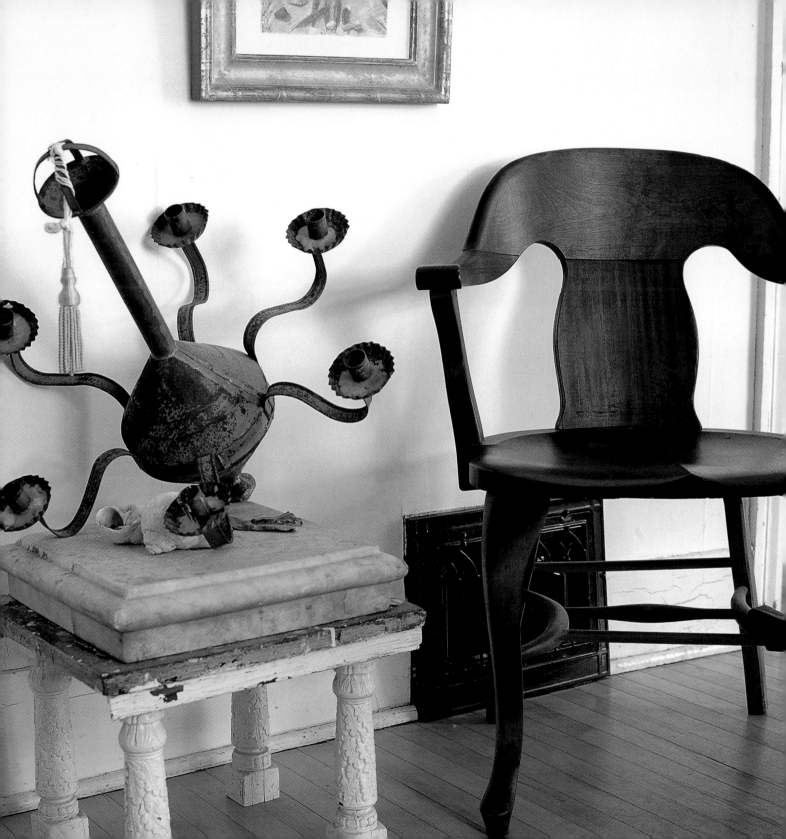

In the abstract, chandeliers can be thought of as sculpture. In a beach town cottage, this **FOUND OBJECT**—a metal chandelier—sits on a table like a piece of art. It is particularly effective because it echoes the curvy arms and legs of the chair.

A flea market find, this iron cage

is outfitted with a bulb and used

as a chandelier in the dining room.

The pale green color and

CURLICUE

metalwork is reminiscent of a garden

gate and enhances the touches of

green used in the table setting.

Bringing the spirit of the outdoors

in helps pass long winter evenings.

Photo: Greg Premru

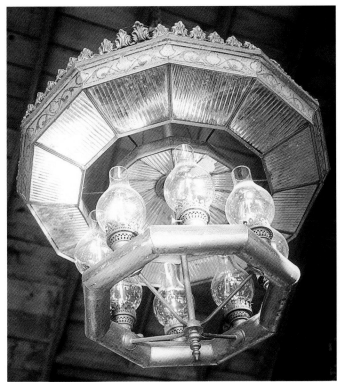

Photo: Antoine Bootz

FLEA MARKETS AND YARD SALES

Flea markets and yard sales are great venues for finding antique chandeliers. Here are some tips for successful hunting:

↔ Wear comfortable shoes, slather on sun block if the event is being held outdoors, and get there early. If you're really organized, pack a lunch. If not, at least bring a big bottle of water.

↔ Don an aura of "knowing what you're doing," even if you don't. The earlier you get there, the more dealers you'll be competing with.

↔ Get the lay of the land—start at one end and go up one aisle and down the next. Then, head back, stopping only at the tables or booths with stuff that interests you.

↔ Scan booths before entering. Chances are that if you aren't intrigued immediately, it's not worth venturing in any further. By doing this you run the risk of not finding that hidden treasure buried among the junk, but we've found that it's more important to find the kindred spirit—the dealer who likes the kind of thing you like—rather than scavenging.

This chandelier was **RESCUED** from a bank building in Connecticut. The ribbed mercury glass that lines the inside of the chandelier reflects the candlelight that the oil lanterns shed. It's perfectly suited to its current home—a cottage in the country.

Though they don't exactly qualify as chandeliers, these lanterns are great stand-ins for the real thing when a quick fix is needed. Hang them over the dining table—until the real thing comes along—and

TRANSFORM

a simple Saturday supper into a special occasion.

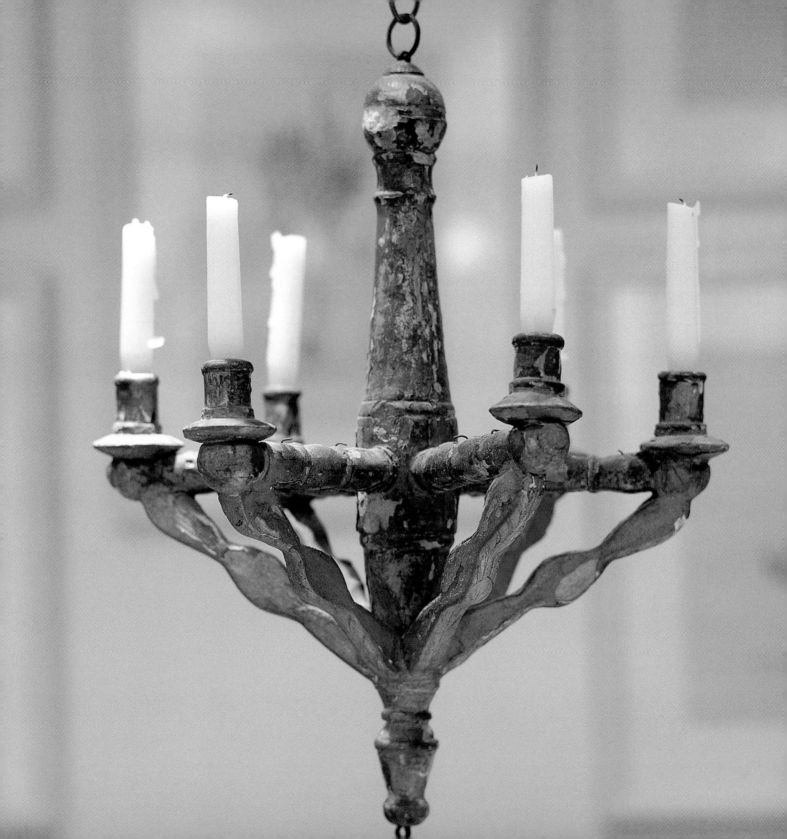

There's something achingly romantic about the combination

of candlelight and the slightly crumbling quality of this

antique chandelier. It's as if the piece has been witness

to a whole host of dinner parties, not to mention trysts.

If you're lucky enough to find one, don't try to clean it up

or electrify it. Use it as is. It can work its M A G I C

in all places in the home.

CANDLES

When considering a chandelier, the scale becomes important on a number of different levels. The most obvious is: does it fit the scale of the room? No less important is the scale of the chandelier's details—shades, crystals, beads, and candles. Candle slips are readily available in plastic, but taking the time to find ones made of wax is well worth the effort. Here is a collection of beeswax candles in various sizes and colors. When in doubt, follow Goldilocks's lead. Try each one out until you realize which one is too small, which is too big, and which is just right.

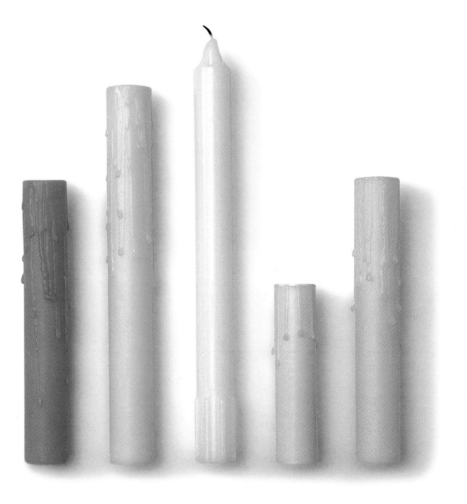

BULBS

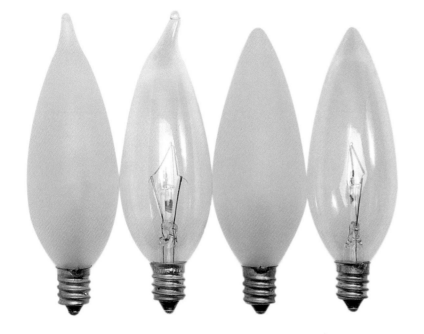

Although there are many types of candelabra base lamps—commonly referred to as bulbs—that fit chandelier sockets, the types most frequently used are torpedo-shaped and flame-tipped, each either clear or frosted. They are made as 15-, 25-, 40-, or 60-watt bulbs. When a chandelier calls for shades, use a torpedo shape. If the bulb remains exposed, your best bet is the flame-tipped variety. Clear lamps produce a cleaner, sharper light. For softer, more diffused light, choose a frosted bulb. Professionals recommend using a higher-wattage bulb on a dimmer, which will allow the bulbs to last longer.

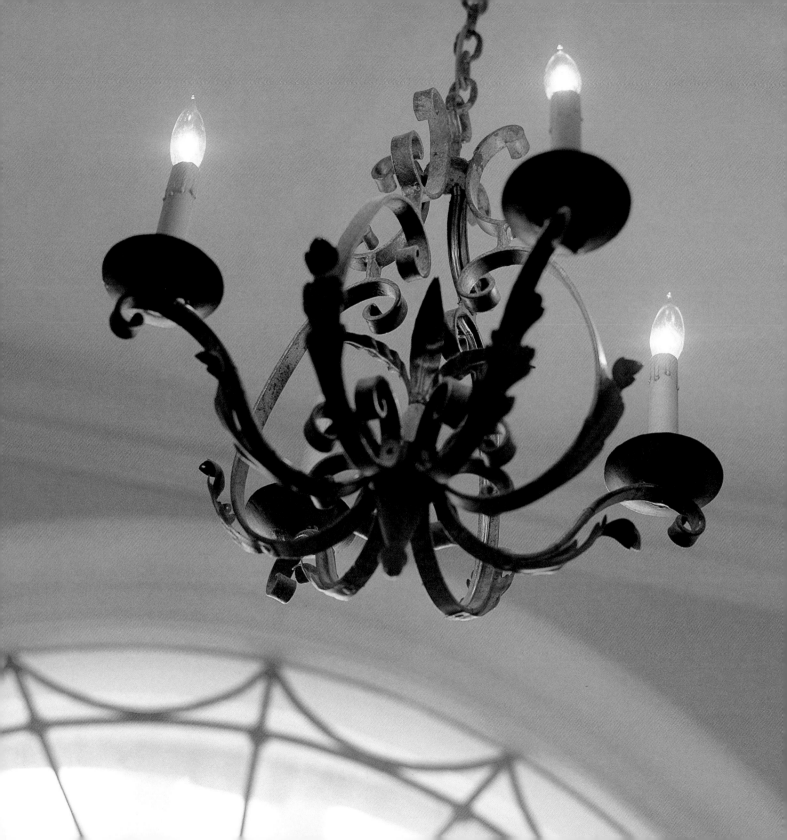

It's all in the details. Like many antique fixtures, this chandelier from France has been electrified. The wiring has been carefully concealed and even the candle slips look authentic. Chandeliers like this, with their lovely patina, work in many rooms of the house. For pure ROMANCE, try hanging one in a bedroom.

This corroded curlicue chandelier acts as a romantic centerpiece to a residential library with a Victorian decorative scheme. As the chandelier is far more rustic than the formal room it occupies, the juxtaposition of styles is surprising and refreshing. Like putting a French Empire style chandelier in an industrial loft, it takes a certain amount of DESIGN CONFIDENCE to mix styles so deliberately.

↔ If you're insecure about how to mix styles, starting a file of tear sheets (pictures torn from magazines) will help. Designers do it all the time. They look at as many pictures as they can before putting together a scheme for a client. Tear sheets serve as inspiration. Not only do they offer a wealth of ideas, but along with the resource guide usually found at the back of any design magazine, they can help you locate exactly what you're after.

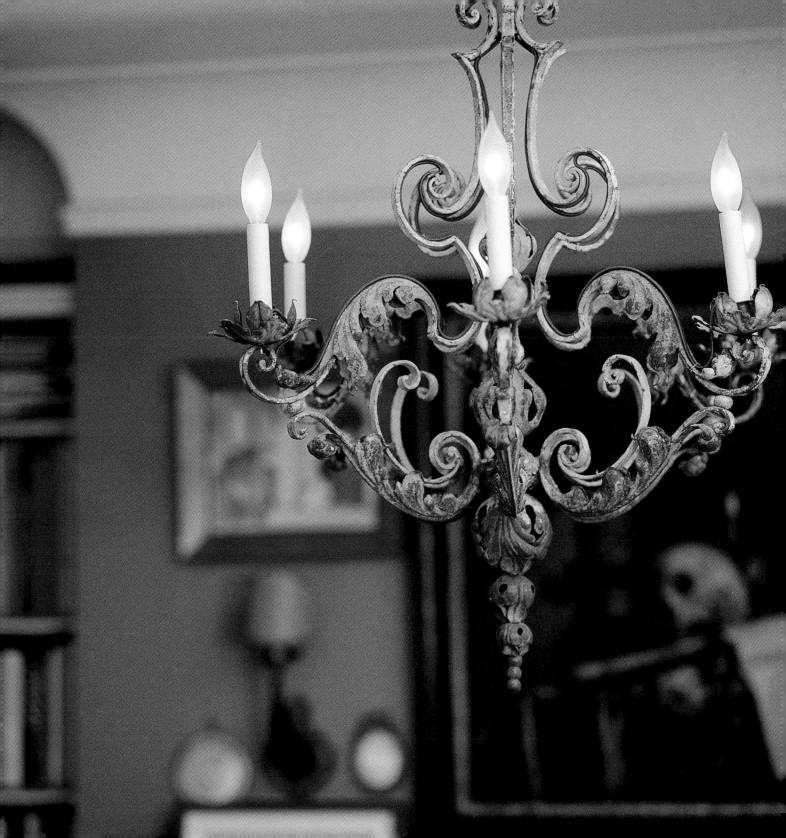

Scale considerations are really a matter of common sense, but at the risk of stating the obvious, it may be worth pointing out a few things. The first has to do with shopping. Retail spaces are often a vastly different size than your house. An elegant chandelier hang-ing in a store or showroom may look just right to you, but keep in mind that scale is relative. When you get it home, it may seem enormous.

How to Shop for a Chandelier

To avoid this problem, don't rely on your scale memory when you shop. Before you embark on a shopping expedition, determine how large a chandelier you want. One way to do this is with a tape measure or yardstick and a partner. Position yourself in the room about where you want the chandelier to be placed. (This may take a stepladder to accomplish.)

Checking Size

Using your hands, try to demonstrate the height of the fixture you think might be right-upper hand with palm facing down, lower hand with palm facing up, fingers outspread and slightly curled to imply a spherical shape. Ask your partner to stand across the room and determine if that size would work. If he determines it does, have him measure the space between your hands. This is by no means a foolproof method, but it will give you some parameters to begin to narrow the possibilities.

Working with Visual Space

Once you've determined the size you think you want, the second issue to consider is visual space. The apparent size of a chandelier is not just a function of its actual measurements, it is also about density. A delicate wrought-iron chandelier may have a large diameter, but doesn't take up much visual space. It is a fixture better described by lines than by volume. You can see right through it. On the other hand, a small, colorful, glass-drop-and-bead-laden chandelier takes more visual space than its size might warrant. When you walk in to the room, you can't miss it. If it is also considerable in size, it may be more than you bargained for, diminishing all the other decorative elements in the room.

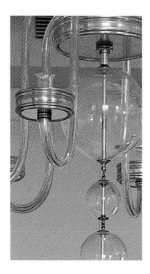

Clear glass objects used as a centerpiece down the middle of a dining table echo the

TRANSPARENCY

of the chandelier above. Using materials in the room that are sheer and reflective and a palette that is monochromatic is a very modern approach.

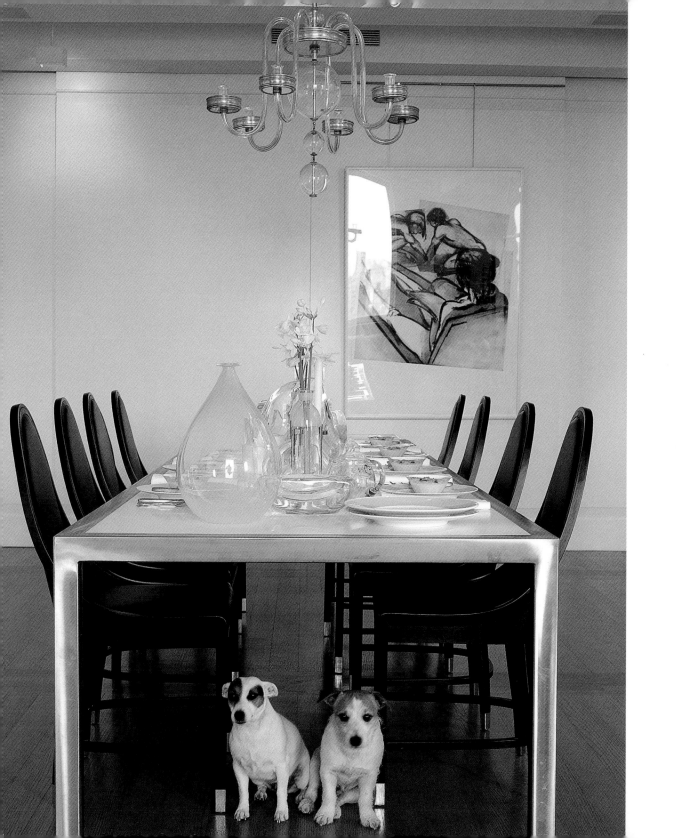

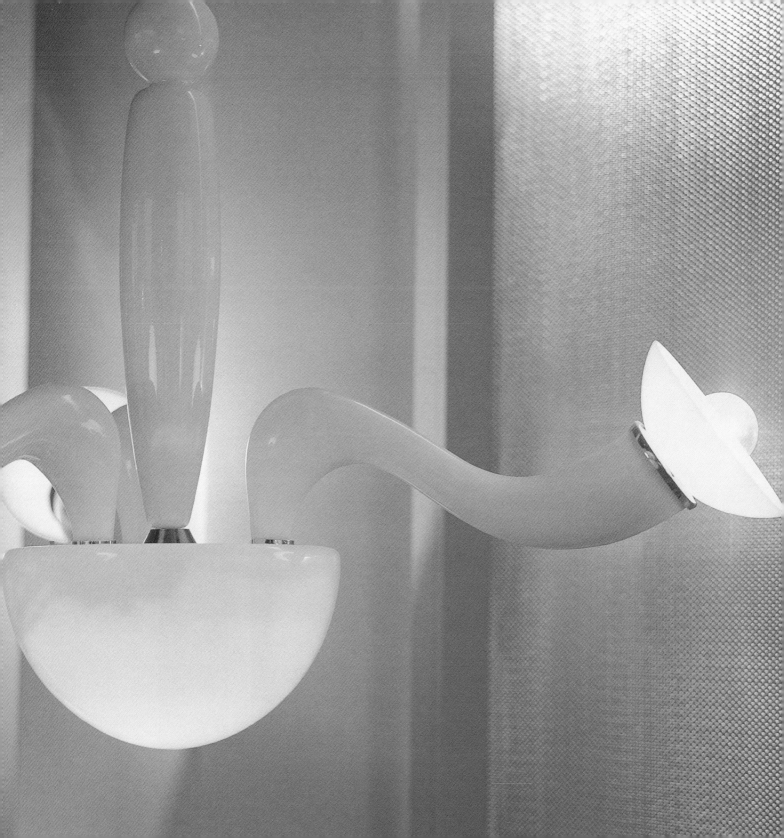

This Italian chandelier enhances a monochromatic room, referencing light, air, and space. This sensibility is heightened by the **WHIMSICAL** nature of the chandelier. The shapely curve of the arm ending with the unusual tilt of the bulb creates an amorphic shape.

When we think of Murano glass,

we usually think of ornate designs.

This example of a mid-century

Murano glass fixture belies that notion.

Though the pattern on the glass is

INTRICATE, the fixture

itself is extremely **SIMPLE**.

It acts as an antidote to the

hallway of a late-nineteenth-century

Victorian townhouse. The top-lit

oversized pendant hanging from the

bottom of the fixture is an lesson

in the effect of light on a sphere.

CHANDELIERS

72

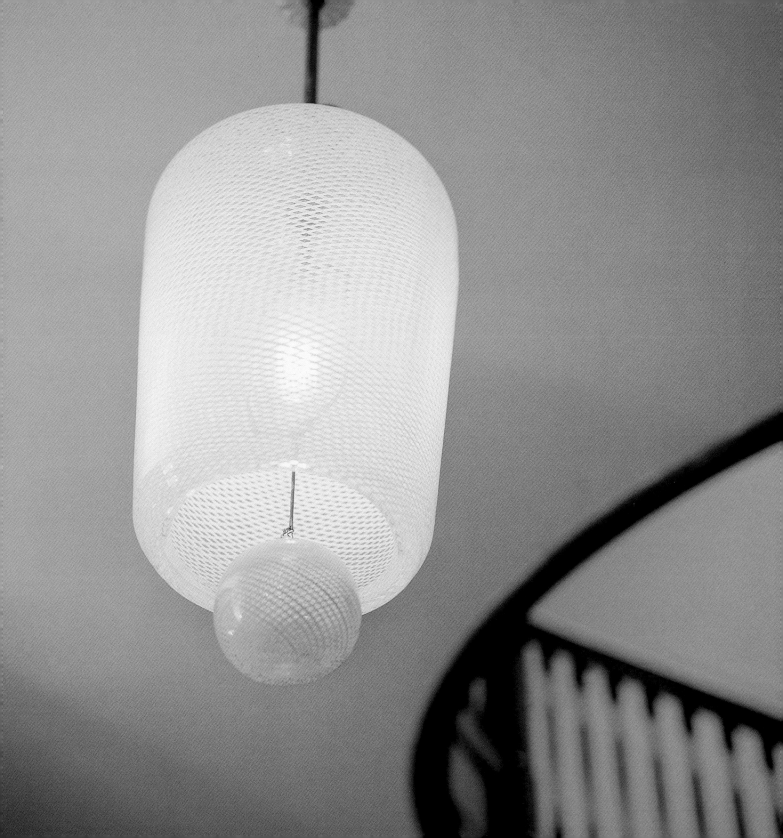

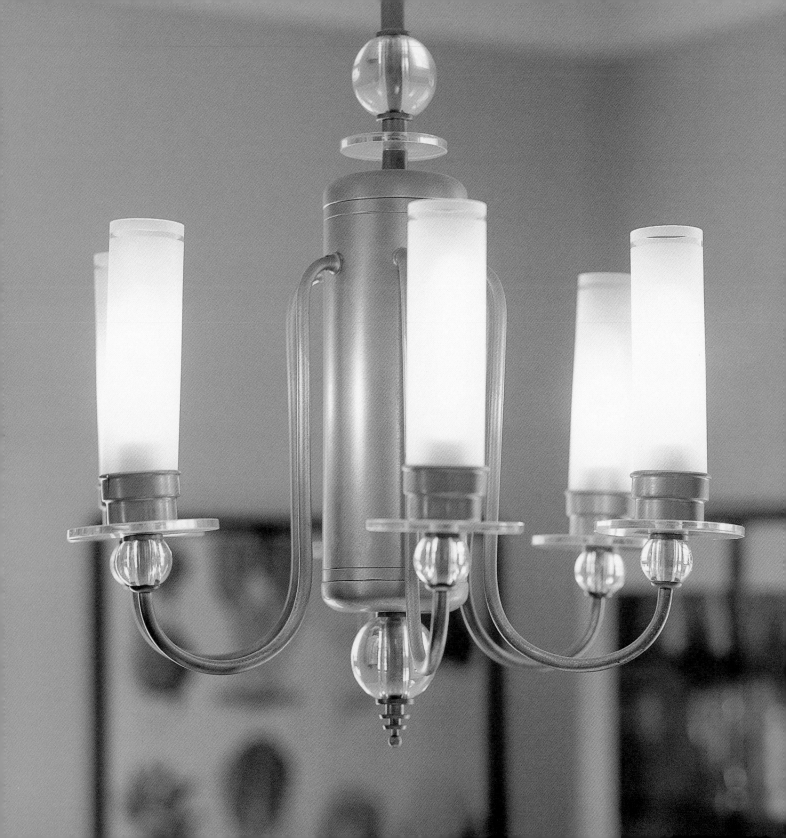

A perfect confluence of tradition and modernism, each element of a traditional chandelier has been transformed. Where there would have been glass prism or crystal drops, there are glass spheres, and where there would have been cup-shaped bobeches, there are flat, circular planes of glass. The six arms, each with a tight upturned radius and hanging close to the tall central cylinder that the arms are attached to, and the narrow, cylindrical frosted-glass hurricanes, allow this chandelier to remain SPATIALLY COMPACT while maintaining as much presence—and giving as much light—as a larger fixture.

Like the neck of a swan, or the outstretched arm of a ballerina, the extended curved glass arms of this 1940's Murano glass chandelier are truly graceful. The eight outstretched arms with simple bronze fittings act as an elegant canopy over diners. The typical way of a suspending a chandelier is from a chain, which, no matter how delicate, is associated with strength. The finely detailed silk cord and tassel from which the chandelier is suspended gives it an ethereal quality, reinforcing the already WEIGHTLESS effect of the tapered clear glass.

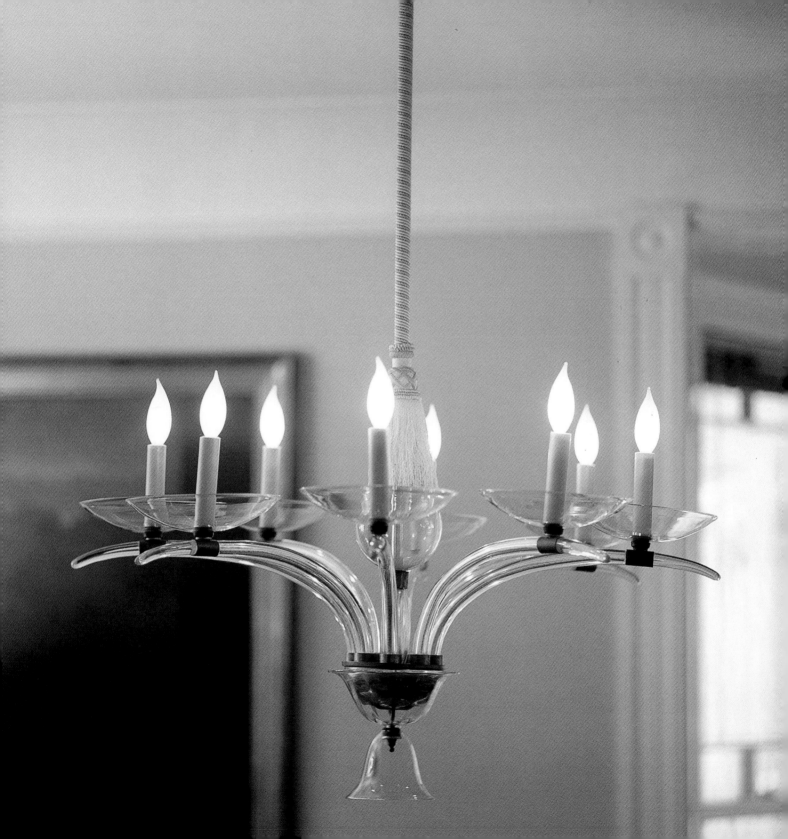

CHAINS

In our first apartment, the kitchen table was illuminated by stringing a light bulb on a wire up the wall and dangling it from a hook in the ceiling. Of course style was a consideration—we did cover the bare bulb with a paper shade. At that point, an electrician was not an option.

While where to hang a chandelier is a major design consideration, so is "how." There are various ways to suspend a chandelier, but the most popular is with chain. It need not be the standard-issue brass version, however. Chains come in various styles and finishes. When choosing a chain, consider the size and visual weight of the chandelier. In most cases, using a chain with the same finish as a chandelier is the best bet. For a more formal effect, a fabric workroom can make a ruched sleeve or sheath to cover the chain, usually in the same or similar fabric to one in the room.

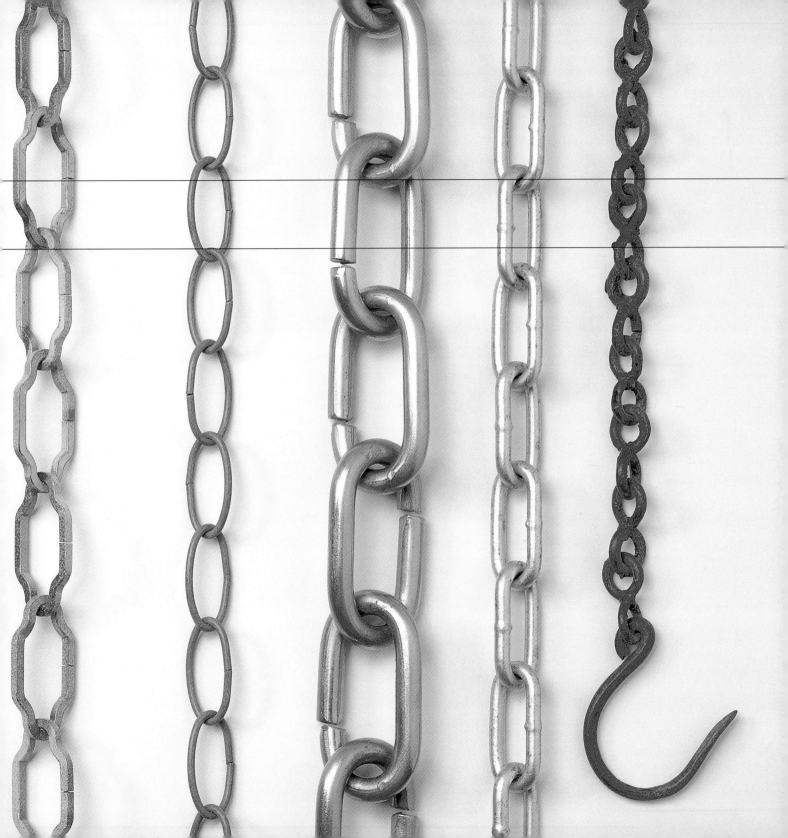

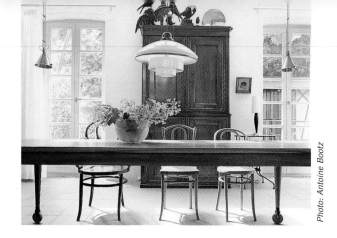

Photo: Antoine Bootz

Common design sense tells us to hang a chandelier over the center of a dining room table. Indeed, in any new house the builder has likely placed one junction box in the center of that room. But sometimes a single pendant over a rectangular table doesn't work. Manufacturers have responded by producing double and triple fixtures that are attached to a single power source, the kind of fixture you might see over a billiard table. But sometimes the Victorian style of these fixtures doesn't work. To overcome the problem, consider using MULTIPLES of the same fixture or even a series of different fixtures. This may call for some rewiring to get the junction box in the right spot, but the effect can be well worth the trouble.

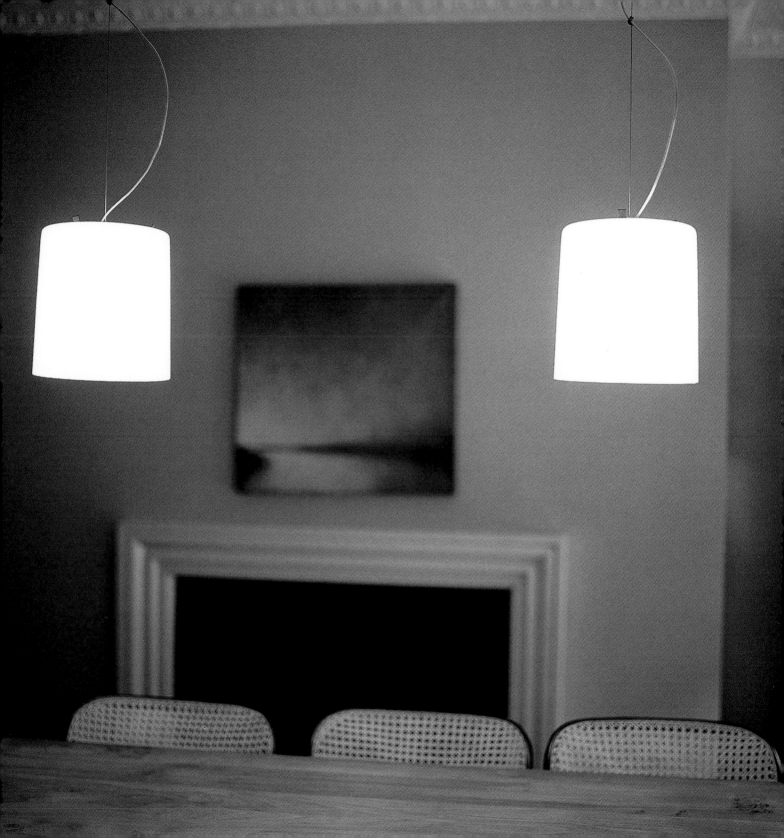

Where to Hang a Chandelier

A chandelier is usually a significant part of a room's decorative scheme and has a strong visual presence, so exactly where it goes in the room is an important design consideration. The first thing to consider is the wiring because it involves not only electrical work, but often carpentry, plasterwork, and painting. So where to place the junction box, which will determine where the fixture will be hung, is something you want to get right the first time. This is often a decision that needs to be made during construction or renovation and so it is often made in advance of choosing the exact fixture. You can make this decision while you're standing in the room with your contractor, but it might be better to start thinking about it with the aid of a floor plan.

Using a Floor Plan

If the chandelier will be hung over a table—either in the hall a dining room—it is important that you determine the exact placement of the table, because the chandelier, in turn, needs to be centered over it. The table and chandelier together become an inseparable unit. Generally, chandeliers over tables are hung below average head height so if you move the table, you'll bump your head. Chandeliers that are not exactly centered over a table look awkward and poorly planned. Using a floor plan, you can make sure that there is adequate space to walk all around the table if it's in a hall or library, and room for chairs in the case of a dining table. There has to be enough room around the chairs, even when they're occupied, to pass by. Once you've placed the table, the chandelier simply gets centered above it. If you are uncomfortable using a floor plan, a large piece of cardboard cut to the size of the table works just as well.

PLACE

MENT

Height Adjustment

The second consideration is the height, but that is easier to determine once the exact fixture is chosen and it is easier to adjust later. "How high should I hang the chandelier?" is the design question we most often encounter. If it is hanging above a dining table, the lowest point of the chandelier should be 36 inches (91.4 cm) above the table surface. This ensures that the chandelier feels connected to the table in the room, but that diners can see across the table when seated. If the chandelier is in a living room or library or den, it should be hung high enough to walk under comfortably—high enough that it is not in your peripheral vision, making you want to duck every time you pass under it. Rather than being concerned about the furnishings below it, it should be centered in the room or aligned architecturally. In other words, if there are significant architectural features in the room—a fireplace, an arched opening, a pair of windows—use those as your guide for placement.

Often referred to as the "artichoke" for
obvious reasons, this Poulsen fixture has been
stylish for so long it that it has become a

DESIGN CLASSIC.

Though constructed more like a lantern than a
chandelier, the metal leaves act like the glass
drops of a traditional chandelier by reflecting
the light in many directions. The white fixture
is tucked into a pocket of space in the ceiling
of a bedroom, its warm light blending with the
deep yellow silk walls.

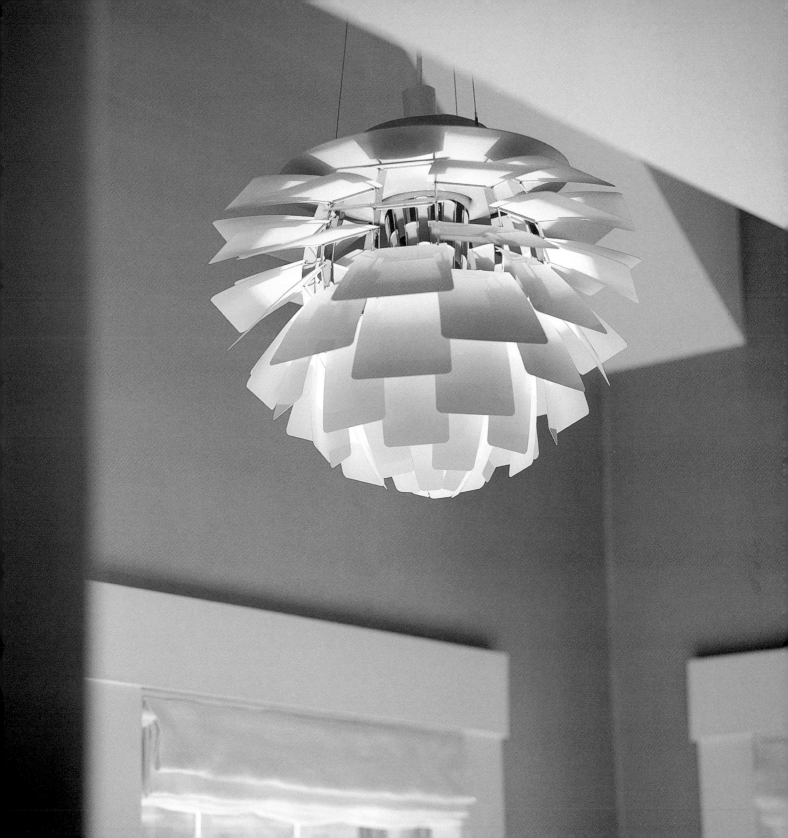

Paper shades # FILTER AND SOFTEN LIGHT.

By using a long narrow shade between two windows, a column of

light was created in this bedroom. Though not technically a chande-

lier, the pendant fixture acts like a chandelier by making a special

place of what otherwise might just have been the corner of the room.

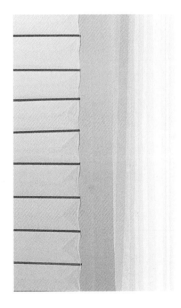

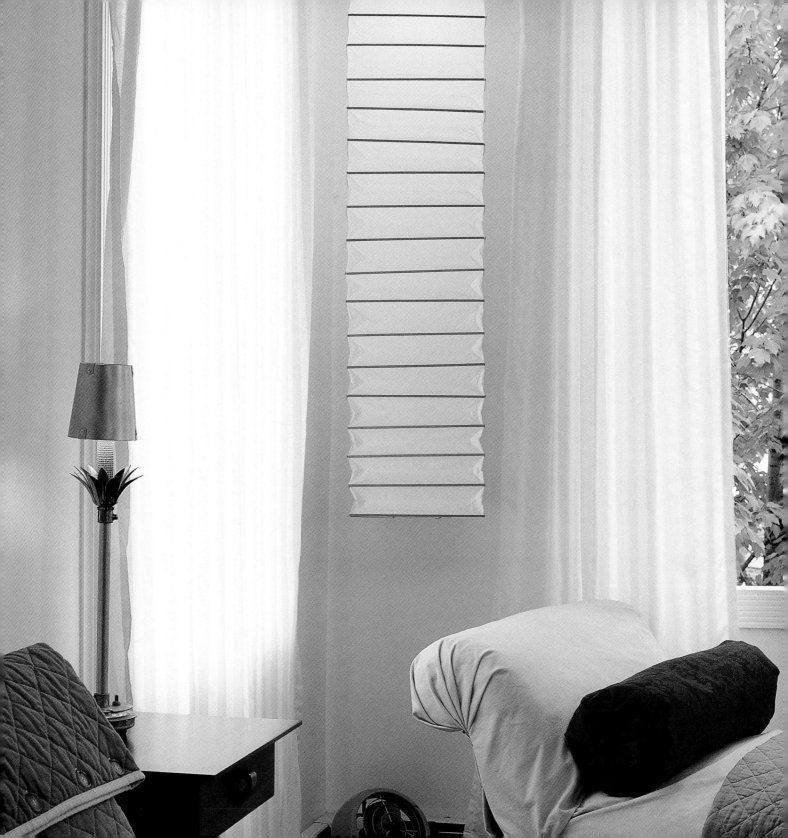

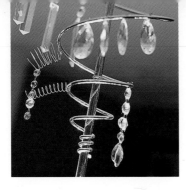

The orange silk curtains and high-back burgundy chairs, topped with a Z A N Y modern crystal chandelier, make this room feel like it is dressed like a woman in a ball gown and tiara. And like a diamond tiara, it's hard to take your eyes off this unusual fixture. A halogen lamp in the chrome bowl up-lights the dangling beads and crystals and the spiral chrome structure that supports them, making the whole thing sparkle.

↔ Whimsy is highly underrated in the design world. Design magazines rarely talk about it. Designers never mention it. It's as if the whole notion will render the designer unprofessional, or worse—lightweight. Ironically, whimsy is what everyone who is not a design professional wants to live with—there are enough things to be serious about in life. It's true that if a whole room is whimsical, it will soon get tiresome. But a little goes a long way. Consider a wacky chandelier. A clever take on a traditional chandelier that is laden with crystals, this modern version is replete with every color and shape of crystal imaginable. Add a spiral structure to the myriad of crystals, and this chandelier will make you smile every time you encounter it.

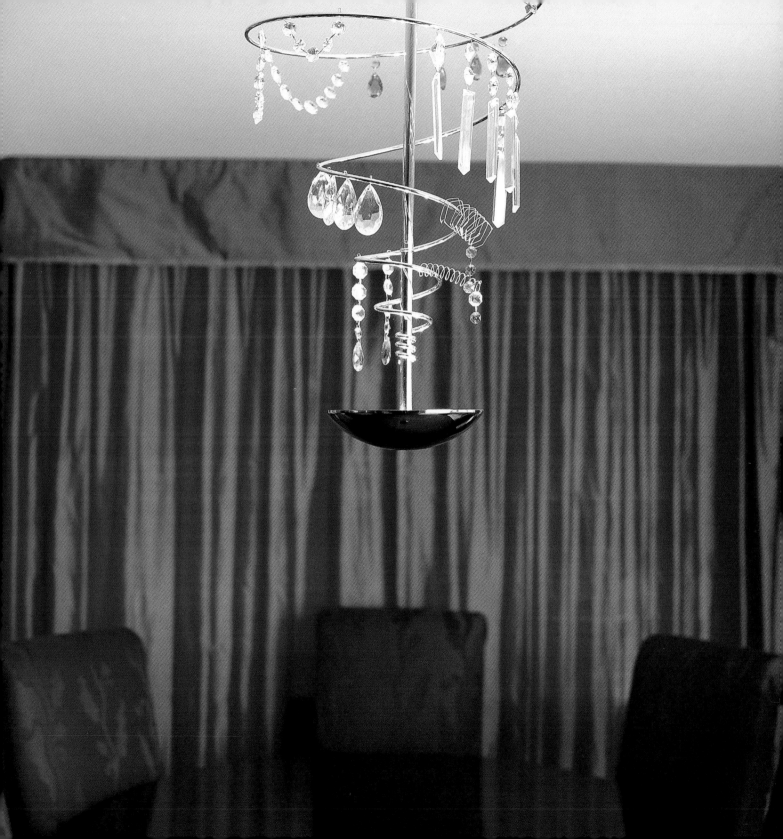

With the chandelier as chief instigator, this room is the epitome of ECLECTIC design. Designer Philip Miller has paired a Philippe Starck dining table from the 1980's with a Boris Sipek Venetian glass chandelier. These icons of high-style modernism are dropped into an environment of chair rails, built-in china cabinets—filled with china—and gold-leaf picture frames.

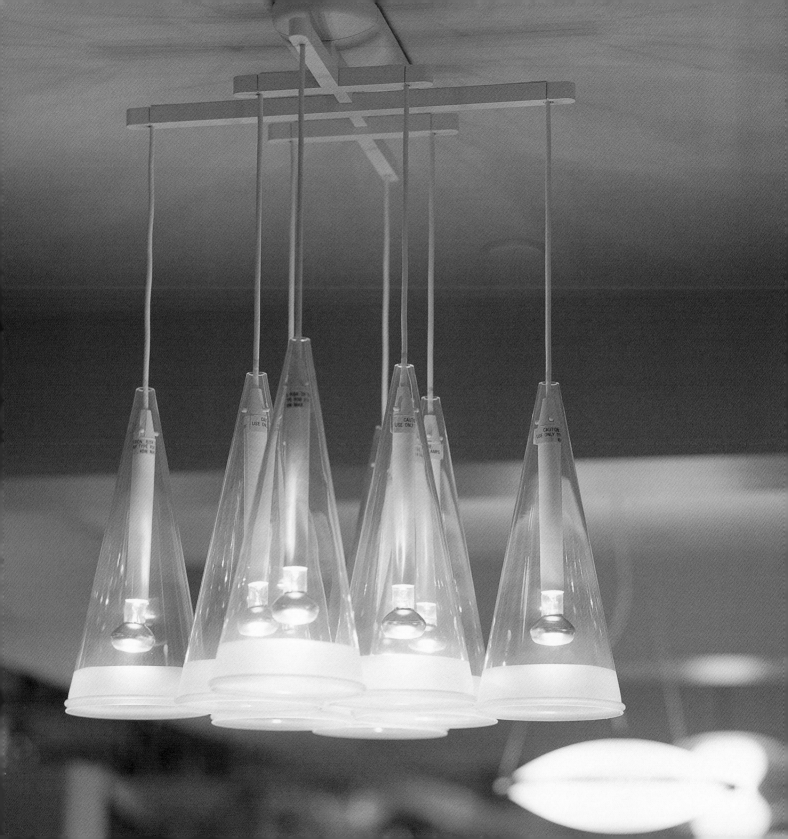

If the word "chandelier" conjures an image of a formal room, this fixture **CHALLENGES** that image. The frosted band at the bottom of each glass cone acts as a lampshade. The eight light sources distribute light through a room the way an eight-arm chandelier might. But formality is not just the purview of traditional decoration. A modern room can also be designed for formal use, in which case, a modern chandelier like this one is exactly what is necessary to complete the look.

↔ Can a chandelier be modern? There is a general notion that chandeliers are old-fashioned and should only used in "period" decorating schemes. If the word "chandelier" conjures images of Newport mansions or Louisiana plantations, consider that a chandelier is basically a fixture hanging from the ceiling with multiple light sources, the light refracted, diffused, or concentrated through translucent materials. That said, there is no reason why we should only think of chandeliers as objects used in traditional rooms when so many modern chandeliers exist. Most lighting stores sell mainly period chandeliers, so you may have to persevere to find the clever contemporary versions.

A tangle of wires and light is the least likely description of

a way to create the perfect atmosphere for a lively dinner

party, but this chandelier challenges anyone to engage in

less-than-sparkling conversation under its happy gaze. Infinite

ADJUSTABILITY is sure to produce unique

lighting effects throughout the room.

↔ In some cases, track lighting might be the best solution because it allows you to highlight particular features in a room. But if the room calls for a decorative fixture rather than something that is simply utilitarian, see if you can find a fixture like this that is cleverly designed with flexible gooseneck material. This fixture allows for the best of both worlds: it is like a traditional chandelier centered in the room or hanging above a table, but its adjustable arms allow you to aim light at nearby paintings or objects.

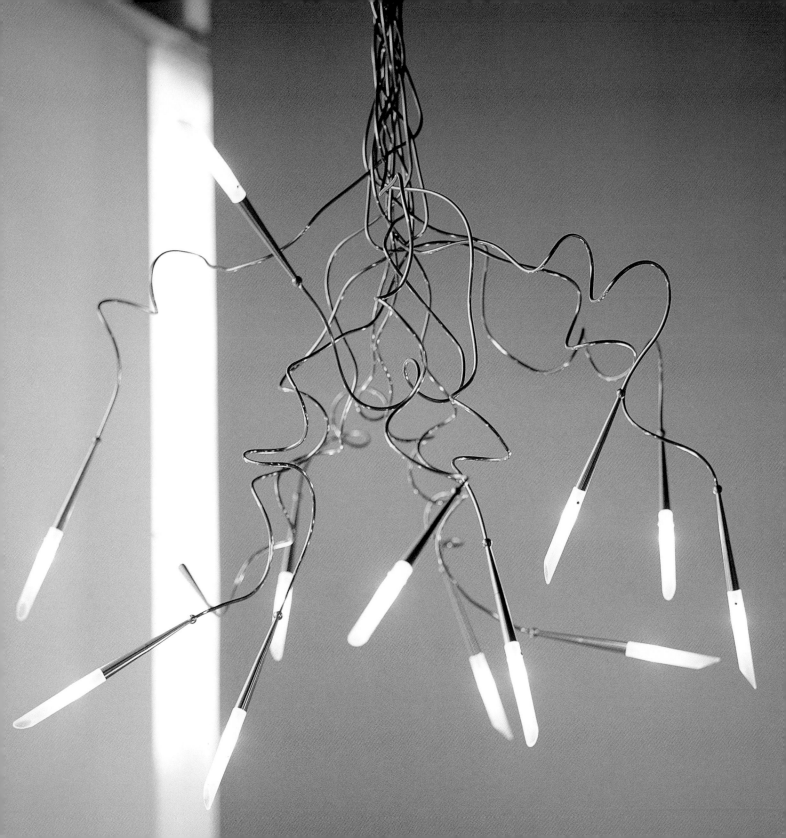

Chandeliers recall grand places and glamorous festivities. They conjure images of great gilded halls with women in ball gowns, men in white tie-and-tails, and an orchestra playing waltzes. The crystal chandelier is in the center of the swirl of activity, lighting and dignifying the space. Along with the violinists and the champagne, the chandelier lends an air of luxury to the scene that is implanted in our mind's eye.

MATERIALS

Placement

There are only a couple of special spots in our homes that we reserve for so grand an object. There is usually one over the dining room table, and there may be one in the hallway. There are many places that a small chandelier would work just fine, but we generally resort to installing a lighting fixture—something that will suffice for the amount of foot candles that is required for the task at hand.

That's really too bad, because a chandelier can do a great deal to help create the overall look of a room, well beyond the amount of light that it sheds. Once we can get past the iconic image of a chandelier overburdened with hand-cut prisms that might only be appropriate for a palace, or a multi-tiered brass chandelier suited for the study of an heir to a corporate dynasty, we can set our sights on a decorative chandelier that will complete—or even compete with—the room scheme. Accepting that chandeliers retain some element of grandeur and luxury, no matter how modest (in the same way that house cats retain some leonine qualities), makes them that much more interesting to incorporate into the decorative scheme of a room. But how do you start?

Matching Material to Mood

The best place to begin to decide what chandelier would work in a room is to narrow down the choice of materials. This is essentially no different than deciding to use mahogany lamp tables rather than glass, but as soon as the decision-making process begins, precedent intercedes. On their own, materials such as wood, metal, glass, and plastic seem neutral with no immediate associations. When paired with other elements of a room's decor, however, they become much more potent. If you think about polished granite countertops, raw steel tables, or cork floors, materials say plenty indeed. Materials are the shorthand system for defining style, but rather than allowing that to be intimidating, let it be liberating. What feeling are you after? What material matches that mood?

When a chandelier is made of corroded metal, it refers to the garden. It's as if a candelabra—freshly painted for an early autumn garden party—was forgotten about until it was uncovered by the gardener the next spring and crudely electrified for use in the shed. As unlikely as the story sounds, a rusted metal chandelier with bits of bright green paint clinging to the crevices, wiring exposed to ensure it's simple pedigree, implies just such a story. If you discovered that chandelier in a country antique market and hung it above a worn wood farm table, the combination of materials in the room would create a rustic, romantic mood.

Modern Takes

Now imagine a cubic white room with a gleaming mahogany floor. Tall windows are covered with panels of linen scrim. A frosted-glass table is surrounded by taupe leather chairs. A sleek modern chandelier is suspended above the table. The chandelier has the basic structure of a traditional one: a center post attached to the ceiling with multiple arms projecting from it. But the fixture is shiny chrome, and at each arm, instead of silk shades or hurricanes as a traditional chandelier might have, textured glass planes and bits of perforated metal break up the light to create alternating sharp and diffused patterns on the ceiling. The chandelier takes center stage, completely in keeping with the other materials used in the scheme, but adding whimsy to a dining room that might otherwise be severe.

Chandeliers can be made of many materials, each with a different effect in the decorative scheme. Paper and parchment lend a casual contemporary air, gold leaf is opulent, wood is warm, nickel is modern, brass is traditional, crystal is formal. But whatever the material, a glittering chandelier always ensures a little magic in a room.

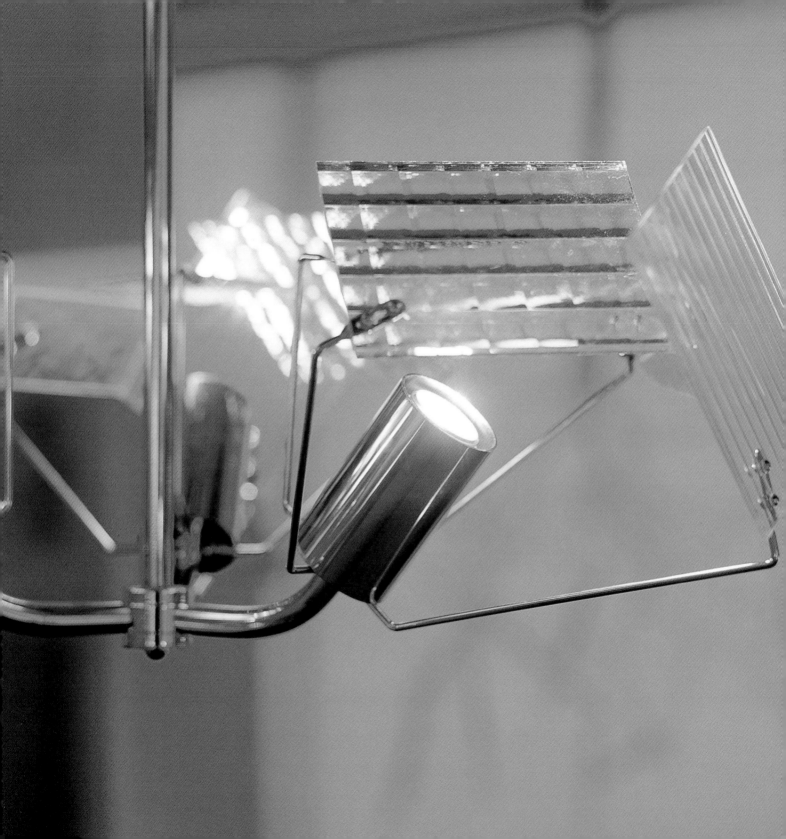

Not as peculiar as it first appears, this fixture

functions something like an eighteenth-century

chandelier. Though the forms are modern in

material and shape—chrome stem, arms,

and cylindrical lamp housing—shooting light

through planes of textured glass and perforated

metal creates an interesting PATTERN

of light and shadow on the ceiling that is

reminiscent of candlelight.

If a client asked us to explain this style of chandelier, we would

have to call it ornamental modernism. The simple D O M E D

shape usually associated with a modern fixture takes on another

personality when covered in small squares of glass joined together

with fine wire. It's the opposing styles, the simple spare shape played

off the delicate covering, that makes this chandelier so appealing.

Photo: Antoine Bootz

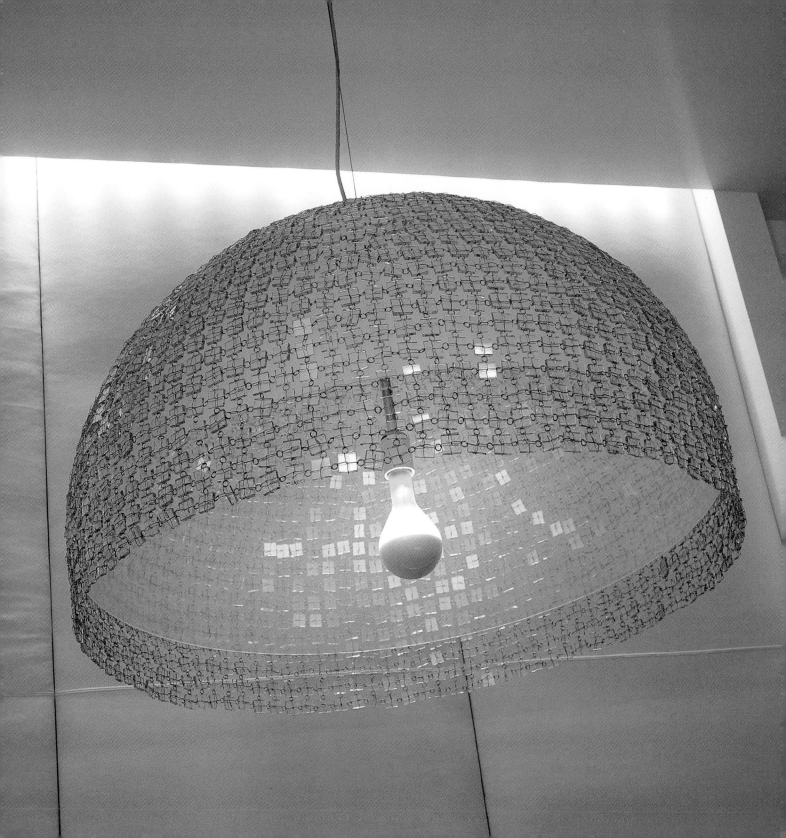

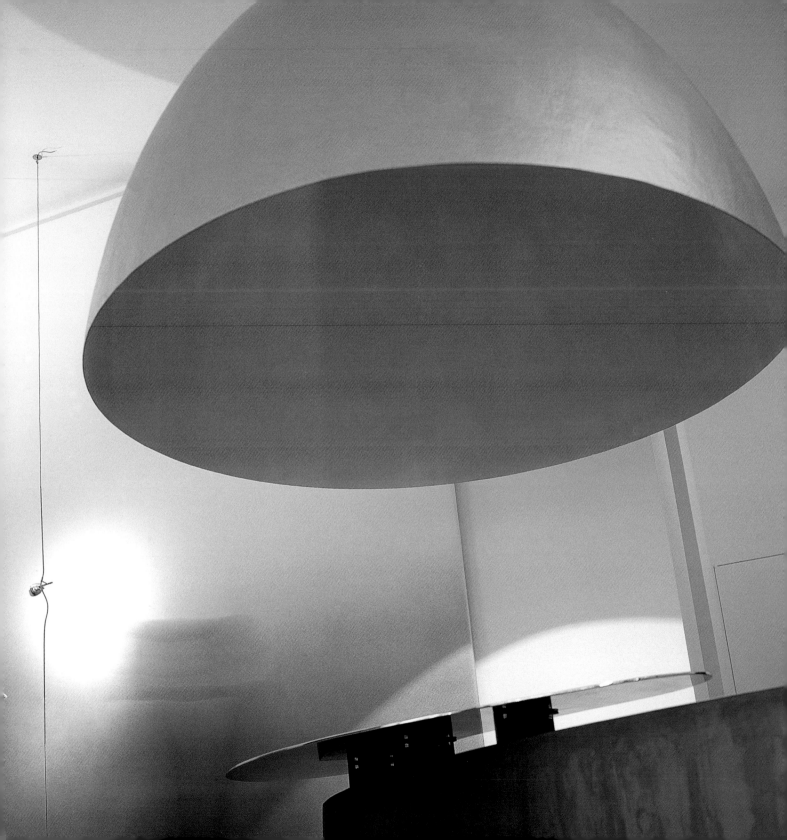

The XXL Dome by Ingo Maurer, with its 180 cm diameter, is almost as large a fixture as you'll find. While we usually think of chandeliers as objects hanging in space, this fixture contains and defines space—more like an

ARCHITECTURAL

feature than an accent.

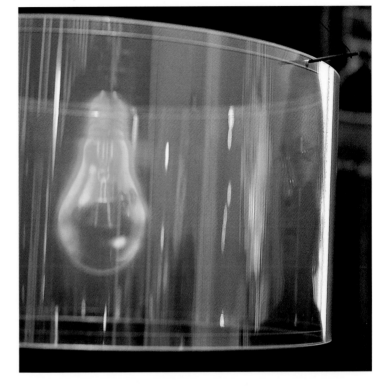

"Wo bist du,...Edison?" is the name of this fixture by Ingo Maurer. It is the ultimate minimal conception of a chandelier: the glass cylinder creates a hologram of an iconic lightbulb, the virtual light source. This fixture is a fitting testament to the fact that Maurer is one of the most creative lighting designers working today. He deals as much with the quality and

CONCEPT OF LIGHT

as he does with lighting fixture itself.

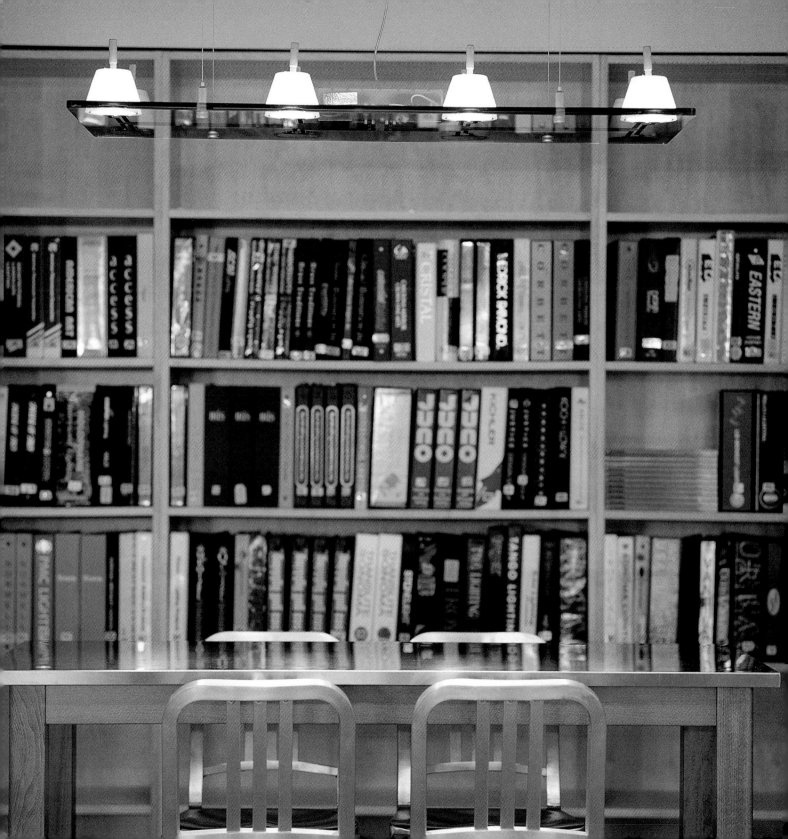

RESOURCES

Just as you might shop for accessories for your wardrobe at a specialty store, so, too would you visit a specialty store when looking for a chandelier. Lighting showrooms offer a whole host of possibilities. If you can't find what you're looking for "on the floor," most good showrooms have a library of catalogues to peruse.

There are stores that specialize in lampshades and, if you're looking for a particular color, shape, or embellishment, many of these shops can make a custom shade for you. If you have the time and the patience, antique stores and flea markets are great places to look for chandeliers. You can often find a treasure trove of antique chandeliers replete with gold leaf or crystals and beads. Below is a list of some of our favorites sources.

ANTIQUE LIGHTING

Antiques on 5
1 Design Center Place Suite 547
Boston, MA 02210
617 951 0008

Blackman Cruz
800 La Cienega Blvd.
Los Angeles, CA 90069
310 657 9228

City Knickerbocker
781 Eighth Ave.
New York, NY 10036
212 586 3939

City Lights Antique Lighting
2226 Massachusetts Ave.
Cambridge, MA 02140
617 547 1490

David Duncan
227 East 60th Street
New York, NY 10010
212 688 0666

Historical Materialism
125 Crosby Street
New York, NY 10012
212 675 8051
www.remains.com

Nesle
151 East 57th Street
New York, NY 10022
212 755 0515

Roosterfish
73 Charles Street
Boston, MA 02114
617 720 2877

Luminaire
301 West Superior Street
Chicago, Illinois 60610
312 664 9582

Roman Thomas
36 East 22nd Street
New York, NY 10010
212 473 6774

Urban Archaeology
143 Franklin St.
New York, NY 10013
212 431 4646
www.urbanarchaeology.com

LIGHTING SHOWROOMS

O'Lampia
15 Bowery
New York, NY 10002
212 925 1660

Chimera
319 A Street
Boston, MA 02210
617 542 3233

Lee's Studio
1069 Third Avenue
New York, NY 10021
212 371 1122

Lee's Studio
1755 Broadway
New York, NY 10019
212 581 4400

Light Forms
509 Amsterdam Avenue
New York, NY 10024
212 875 0407

Light Forms
168 Eighth Avenue
New York, NY 10011
212 255 4664

Light Forms
2331 Ponce de Leon Blvd.
Coral Gables, Florida 33134
305 448 7367

Revco
360 Route 39a
South Hampton, NY 11968
631 283 3600

Tech Lighting
300 West Superior Street
Chicago, Illinois 60610
312 642 1586

Wolfers Lighting
103 North Beacon Street
Allston, MA 02134
617 254 0700

Wolfers Lighting
1339 Main Street
Waltham, MA 02454
781 672 4200

CUSTOM SHADES

Blanche Field Incorporated
1 Design Center Place Suite 336
Boston, MA 02210
617 423 0714

Just Shades
21 Spring St.
New York, NY 10012
212 966 2757

Oriental Lampshade Company
223 W 79th St.
New York, NY 10024
212 873 0812
www.orientallampshade.com

BEADED CHANDELIERS

Canopy Designs Limited
4261 24th Street Floor 3
Long Island City, NY 11101
718 361 3040

Ercole
116 Franklin Street
New York, NY 10013
212 941 6098

Nest
2300 Filmore
San Francisco, CA 94115
415 292 6199

MODERN CHANDELIERS

Artemide SoHo
46 Greene St.
New York, NY 10013
212 925 1588
www.artemide.com

Diva Collection
8801 Beverly Blvd
Los Angeles, CA 90048
310 278 3191

Ingo Maurer LLC
89 Grand Street
New York, NY 10013
212 965 8817
www.ingo-maurer.com

Moss
146 Greene Street
New York, NY 10012
212 226 2190
www.mossonline.com

ABOUT THE AUTHORS

Cheryl and Jeffrey Katz are the design columnists for the *Boston Globe* magazine. Their Boston-based design company, C&J Katz Studio, is engaged in a broad range of work including retail spaces, corporate headquarters, restaurants, residences, exhibits, and furniture. Their writing and design work is centered around the idea that good design should simply be an everyday fact of life. The Katzes are the authors of *Room Recipes: Ingredients for Great Looking Rooms*. They live in Boston with their children, Fanny and Oliver.

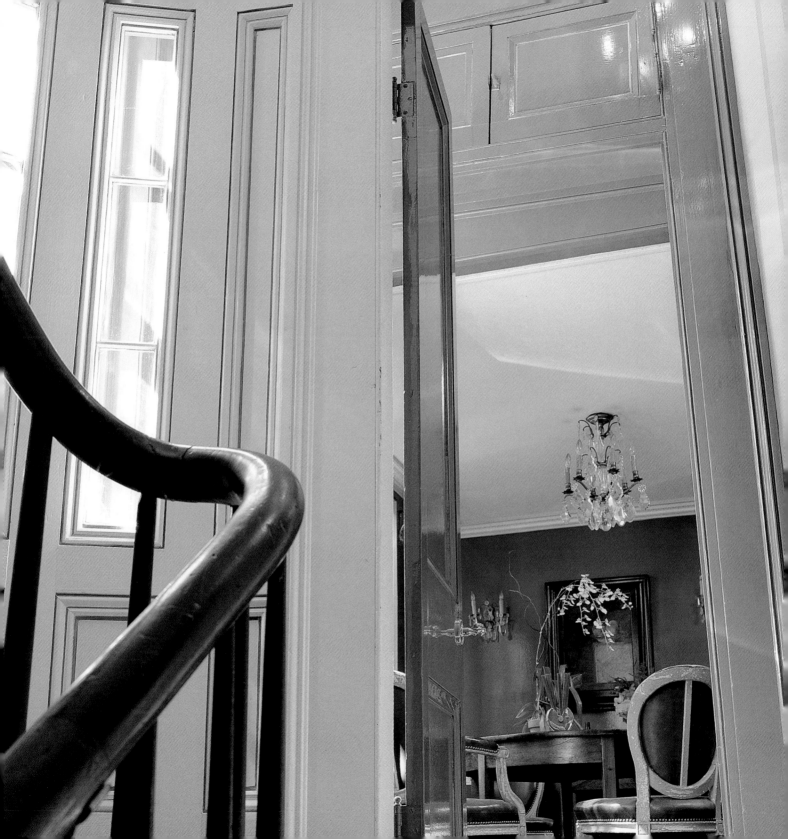

ACKNOWLEDGMENTS

Many thanks are due to the many people who put up with our frantic schedule as we worked on this book. But special thanks are due to Rick Hornick and Sandy Rivlin who bring an elegant vision to the pictures in this book; to Kristen Wainwright, our smart and graceful literary agent; to Josh Feinstein, a superb lighting consultant, who spent an amazing amount of time helping us understand the technical intricacies of lighting; to our friends and colleagues at Roosterfish, Wolfers Lighting and Charles Spada's Antiques on Five, who all allowed us to disrupt their showrooms; to Ric Calvillo, Heidi Wyle, Roldolfo Machado and Jorge Silvetti, who allowed us to disrupt their houses. And to our children, Fanny and Oliver, who once again have, with incredible good nature, endured many late-night take-in dinners and rushed homework help. They are the light of our lives.